THE FINGER LAKES
Revisited

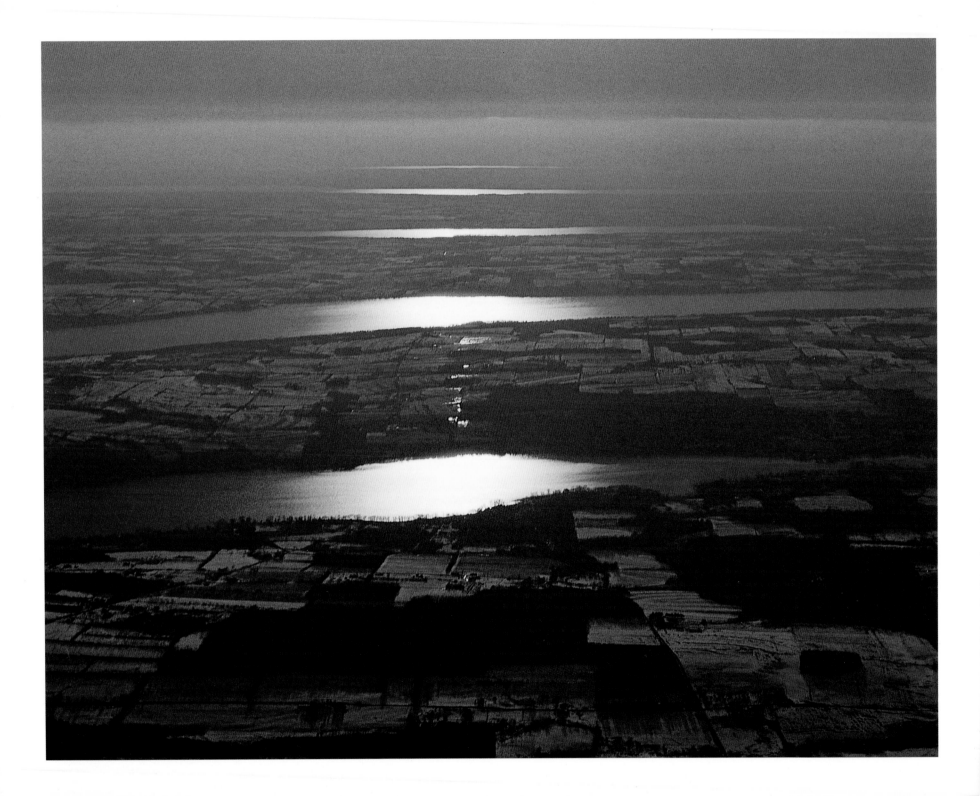

THE FINGER LAKES
Revisited

John Francis McCarthy
and
Linda Bishop McCarthy

Foreward by Conrad T. Tunney

Introduction by Douglas A. Fisher

FINGER LAKES PHOTOGRAPHY

™

Finger Lakes Photography, Skaneateles, New York 13152

©1997 by John Francis McCarthy. All rights reserved
Introduction ©1997 by Douglas A. Fisher.

ISBN 0-9623716-3-7
03 02 01 00 99 98 5 4 3 2 1

Design: ChaseDesign, Skaneateles, New York 13152
Printed in Hong Kong

Photo Opposite Title Page

Five Lakes Sunset
From 2500 feet, I noticed a single shaft of sunlight strike Seneca Lake
40 miles distant before reflecting off Cayuga, Owasco, Skaneateles and Otisco.
This view lasted less than 45 seconds.

Foreward

It's with a deep sense of appreciation for New York's Finger Lakes Region, and in a spirit of sharing its unique treasures, that this forward is written. I've come to know them well over the last 60 years, nearly half of which has been spent in the service of the Finger Lakes Association, a non-profit organization dedicated to the preservation and promotion of the Finger Lakes.

Since 1984 many people have enjoyed its unique offerings, as pictured and presented in an original collection of photographs, *The Finger Lakes,* by John and Linda McCarthy. Their sensitivity for scenes depicting the Finger Lakes, along with their professional skills, reveal the true uniqueness of the natural beauty and man-made appeal of this region. Their portrayal, typifying the variety of scenes in a four-season setting, resulted in an unprecedented interest for their book by both residents and visitors alike.

This updated and expanded edition for the 1990's has resulted from popular demand. There are over 100 photographs, picturing the Finger Lakes as never before. They feature our greatest asset, the water resources, and the Erie Canal.

This book presents the essence of the "Finger Lakes Feeling" and is a tribute to their skills. Whether to whet the appetite or recall fond memories, this Finger Lakes picture book is a possession you and yours can cherish into the next century.

Conrad T. Tunney
Executive Director
The Finger Lakes Association

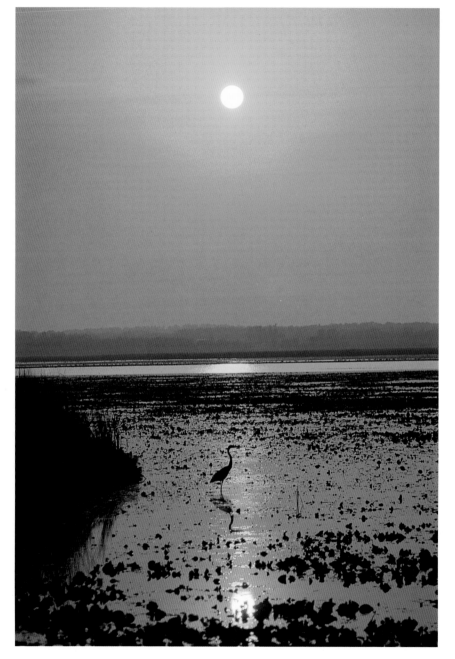

GREAT BLUE HERON

Montezuma Wildlife Refuge

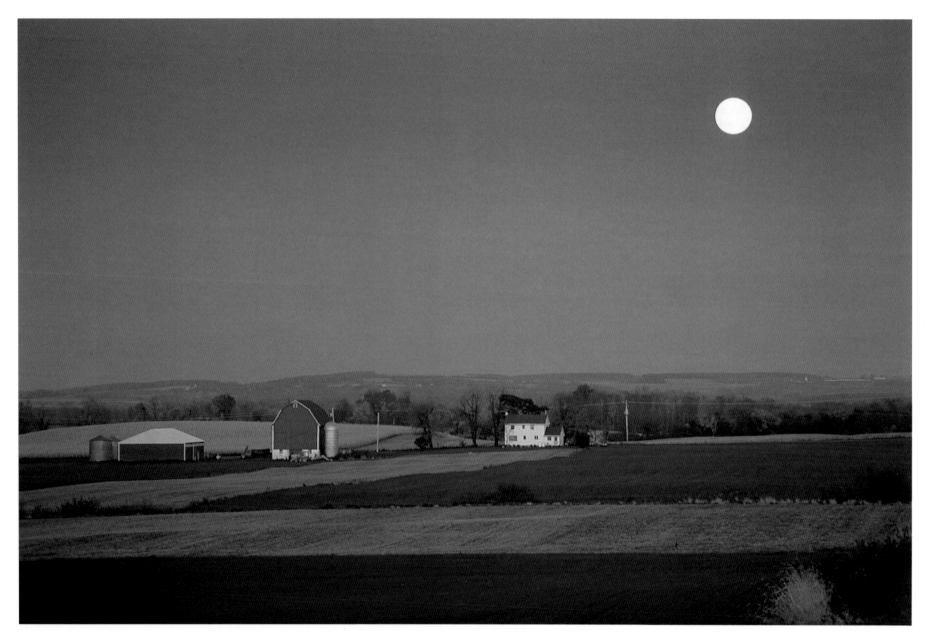

MOONRISE

Near Frozen Ocean, north of Moravia
A few minutes earlier the moon seemed to be nestled in the cornfield.

Introduction

Linda and John Francis McCarthy's latest book on the Finger Lakes provides a special insight into the beautiful and varied scenery of western New York State. As their photographs guide us through the region, we become a part of this nexus of man and geology.

The famed "Genesee Country" of pioneer days included all of western New York, from the Finger Lakes westward across the Genesee River Valley to Lake Erie. Prehistoric glaciers created agricultural conditions highly favorable for settlement, first by Native Americans and later by westward-bound New England pioneers.

The beauty of this region has largely survived the human settlement of recent centuries. The McCarthys' photography depicts an area whose geology is on a human scale. Mountains here are not too steep and rock-filled to deter farming. Nor do we find dramatic ocean ports easily accessible to world commerce. Instead we find a pleasant and scenic agricultural cornucopia, supplemented in recent decades by highly technological manufactories.

A glacial ice slab of two miles in height slid over this region a dozen millennia ago, pushing Canada's rich loam here and leaving Canadian soil the poorer. As the glacier met with New York's bedrock, a tremendous grinding created boulders, cobblestones, gravel and sand. These building materials were already in place when settlers arrived. The cobblestones, created by lake-action abrasion of small boulders, provided the fabric for buildings of a type largely limited to the area south of Lake Ontario.

Cobblestone House, ONTARIO COUNTY

Rocky hills slowed the glacier's leading edge. The ice slid around those obstacles, shaving down the hillsides and backs. This action left hundreds of formations which resemble inverted canoes. Known as drumlins, they are highest on their northerly side, which confronted the glacier.

New York State Route 31 weaves through many of these drumlins. "Hill Cumorah" of Mormon fame is such a drumlin, located on Route 21

south of Palmyra, in the town of Manchester, Ontario County. Water and wind erosion have made a marvelous exhibit of drumlin construction at Chimney Bluffs State Park on Lake Ontario, just east of Sodus Bay.

As the glacial sheet melted, the ice-borne detritus landed upon the non-transformed topography. A crack in the ice molded a ridge of deposits known as an esker. A melthole in the ice let a whirlpool scour out a cavity in the ground known as a kettle hole. Fine examples of these features may be found in Mendon Ponds Park, and over through Fishers to Pittsfords' Powder Mill Park. Such deposits of rock also clogged ancient watercourses. Many of these stream-cut valleys were filled with water from the receding glacier, and the deposited rock caused a slow regulated drainage. These north-south channels became today's beautiful and placid Finger Lakes. Some troughs drained well and have remained dry, such as the Bristol and Middlesex Valleys in the counties of Yates and Ontario.

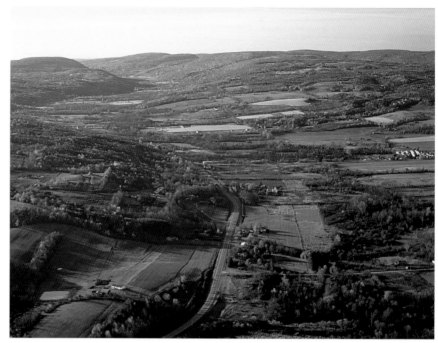

Bristol Valley

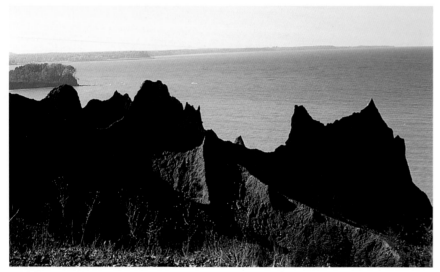

Chimney Bluffs, Lake Ontario

The glacier capped over the prehistoric Genesee River and created the underground Fairchild River. Now used as a soft water supply from the ancient riverbed, this watercourse was discovered by the noted University of Rochester geologist Herman LeRoy Fairchild. The underground river runs from Dansville north to Rush, thence east to Mendon and Fishers, and north to Irondequoit Bay on Lake Ontario. The rocky leavings not only capped the ancient Genesee River route, but also diverted part of the stream through its present cataracty route via gorges at Letchworth State Park and in the city of Rochester.

Lateral channeling of glacial meltwater provided level east-west ground transportation routes parallel to the south shore of Lake Ontario. The Erie Canal followed such a route, bringing upstate produce to the port of New York City and opening up the nation's west. Several decades later the New York Central & Hudson River Railroad followed much the same channel route, but skirted northerly around the great Montezuma marshes. A century later, the New York State Thruway crossed the swamp center. Highway engineers repeatedly watched the roadfill squish into the silted mass of the ancient glacial river. Today's thruway strides atop numerous earthfillings.

Native Americans were the earliest settlers in this blessed land. Successive cultural waves of these peoples can be traced back many thousands of years. About 2,000 years ago the area was home to the great Hopewellian mound builders, whose domain extended to the valley of the Ohio River. The rich soil yielded bountiful crops, and the forest primeval teemed with wild game.

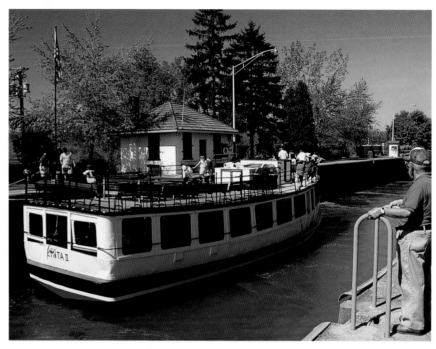

Erie Canal Lock, Pittsford

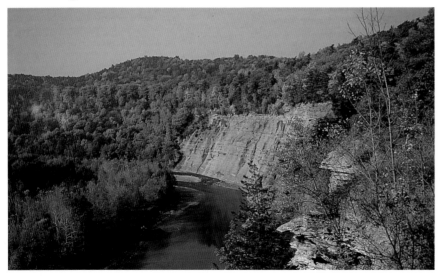

Letchworth State Park

For hundreds of years the Mohawk, Oneida, Onondaga, Cayuga and Seneca have lived in peace with one another under the "Great Law" of the Five Nations. More democratic than the United States governments, this "law" system is still practiced by today's Iroquois Confederacy. The Onondaga Nation now keeps the council fire.

European monarchies sought the riches of this land for themselves. America's abundance of fur-bearing animals seemed a natural substitute for the recently depleted wild game of Europe. In particular, beaver pelts were sought for felt making. The St. Lawrence River and Great Lakes provided direct water passage into the heartland of North America, but

the Iroquois Confederacy controlled the access. As "keepers of the western gate" at Ganondagan, the Seneca were pivotal in determining the fate of the European aspirations for the colonial fur trade.

The French were upset at Seneca dealings with British fur traders and in 1687 set about to crush the power of the Seneca. Under the Marquis de Denonville, Governor-General of Canada, a French army targeted Ganondagan from their landing site at Irondequoit Bay. They met the Seneca in a pitched battle not far from today's Valentown, near Fishers. The armed clash was a draw, and the Seneca retreated under cover of darkness to destroy their village and foodstuffs before the invading French could do the job. This story is interpreted today at the Ganondagan State Historic Site, just south of the village of Victor in Ontario County.

Noted personalities stand out in the region's history. Ji-gon-sa-seh was dubbed the "Mother of Nations" or "Peace Queen" for her role in founding the "Great Law" of the Iroquois Confederacy. According to legend, she was buried in a blanket of fresh water pearls at Ganondagan. One of the world's great orators was the Seneca chief Red Jacket, who lived near present-day Geneva around 1800. President George Washington presented Red Jacket with a silver peace medal, which he often wore. Present-day Avon was the home two centuries ago to Chief Cornplanter and his half-brother Handsome Lake. The latter introduced the "Religion of the Longhouse."

One particularly colorful area personality was Jemima Wilkinson, who called herself the "Publick Universal Friend." As an illiterate twenty year old Rhode Islander, she emerged from a coma and thereupon likened herself to Christ. She gathered a large following from Rhode Island and Pennsylvania, bringing them in 1788 to the town of Jerusalem in Yates County to practice their reclusionary religion.

Legend has it that she once took her followers down to nearby Kueka Lake and asked them whether they believed that she could walk on water. Yes, they said, so she announced she need not do it. The plain-frame Wilkinson mansion still stands on the Friend Hill Road north of Branchport.

Near Seneca Lake at Dresden stands the birthplace of Robert Ingersoll, noted agnostic author and orator, whose speeches and writings were widely followed throughout 19th century America.

From glaciers to pioneers, visitors have left their mark on western New York. Modern development has compromised or destroyed some highly significant sites and vistas. The ancient forests and fauna may be gone, but the lens of John and Linda McCarthy guides us to what may still be seen of our prized homeland.

Douglas A. Fisher
Fishers, New York

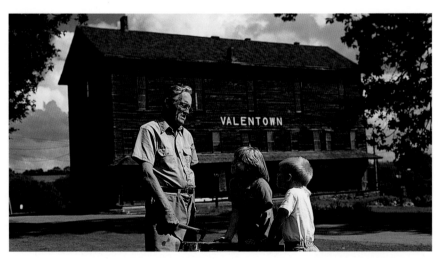

J. Sheldon Fisher at Valentown Museum. Fishers, Ontario County

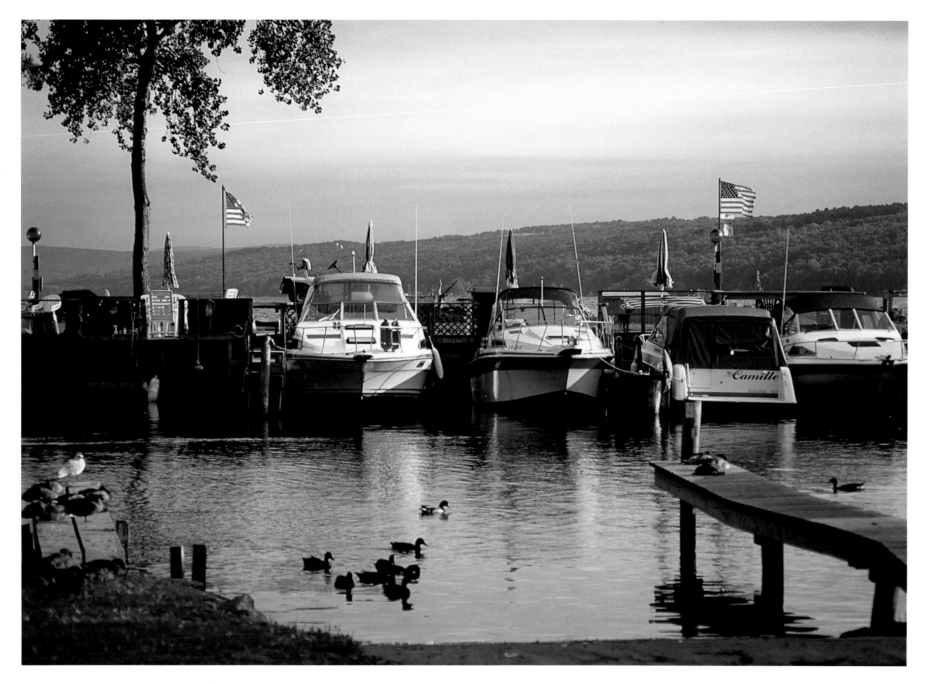

CAYUGA LAKE

A busy day for ducks, gulls and flags on
Cayuga Lake, north of Ithaca.

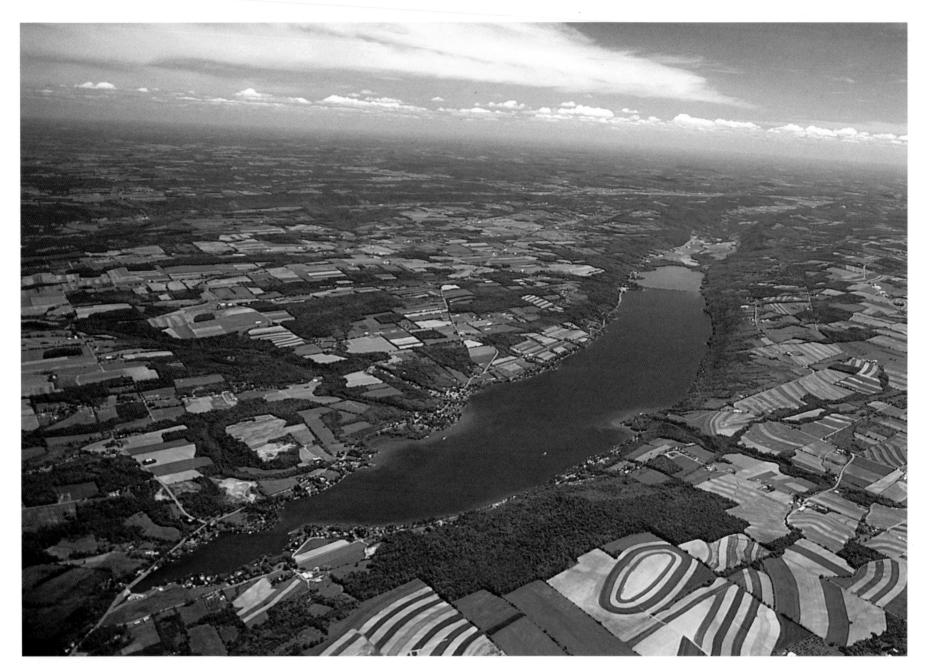

Otisco Lake

Stretching six miles through the fertile Otisco Valley, this eastern-most Finger Lake has a maximum depth of 66 feet.

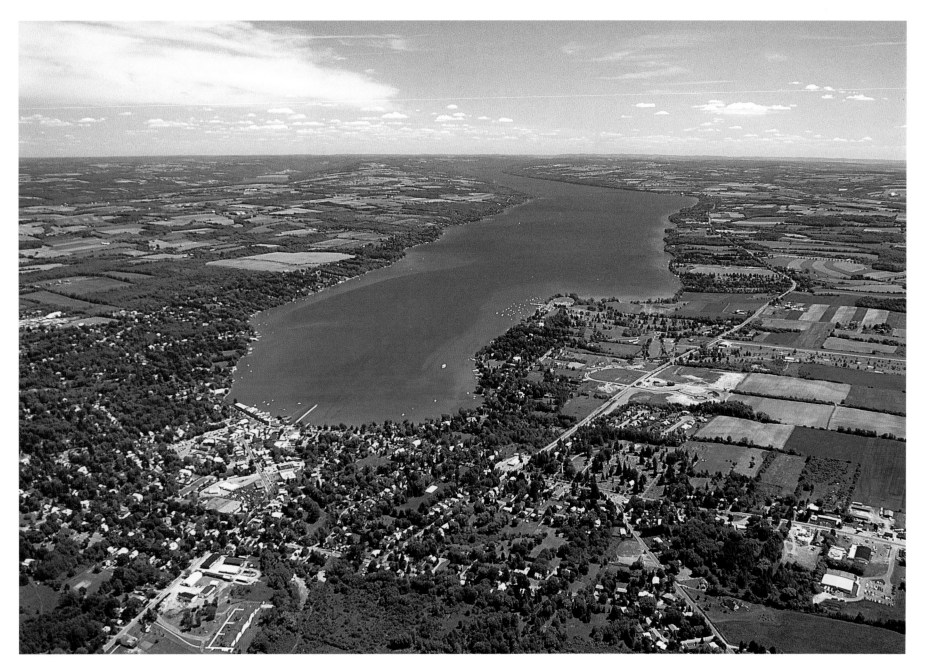

SKANEATELES LAKE

Sixteen miles long, 350 feet deep.
President Lincoln's Secretary of State, William H. Seward, called
Skaneateles Lake "the most beautiful body of water in the world."

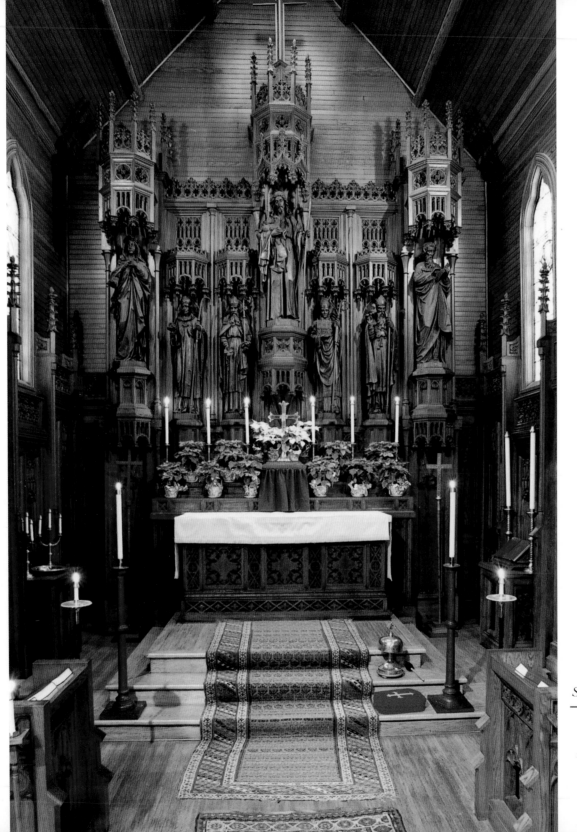

ST. MATTHEW'S EPISCOPAL CHURCH, MORAVIA

Bavarian oak carvings designed and crafted in Oberammergau, Germany, and the carvings of itinerant artist Charles S. Hall are featured in this beautiful and inspiring interior.

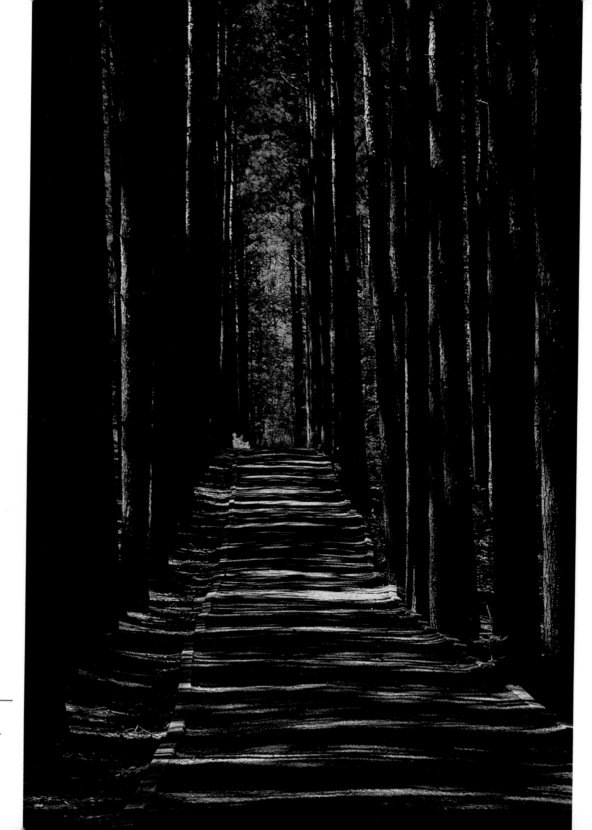

CUMMING NATURE CENTER, NAPLES

Red pine line the entrance to six miles of trail
through wetlands, deciduous and coniferous forest.
This living museum is part of the
Rochester Museum and Science Center.

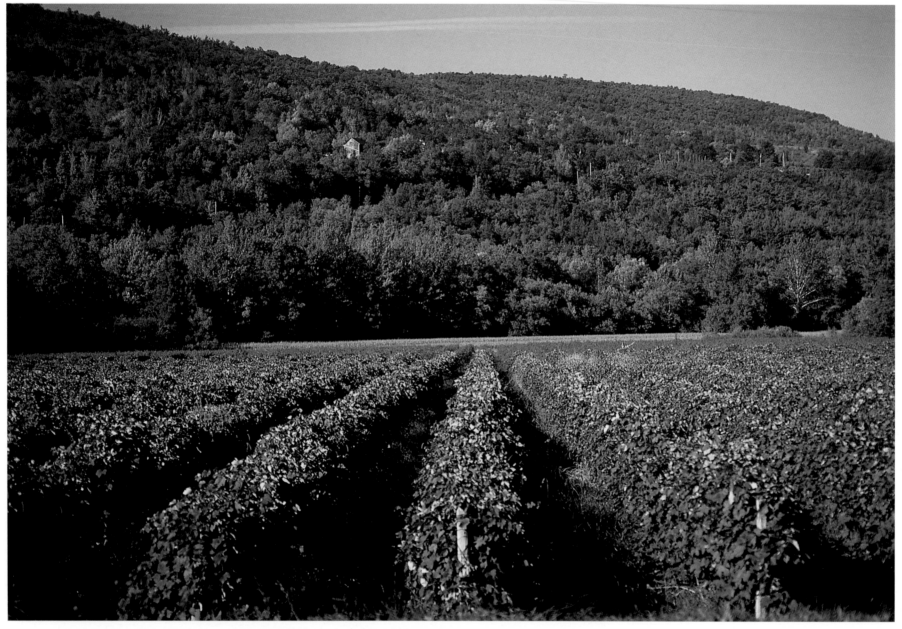

VINEYARDS, NAPLES

With over 10,000 acres of vineyards and 48
wineries, the Finger Lakes region is the largest
wine country outside of California.

HILLSIDE FARM, SENECA LAKE

The ride from Lodi to Watkins Glen features
spectacular panaramas of the lake.

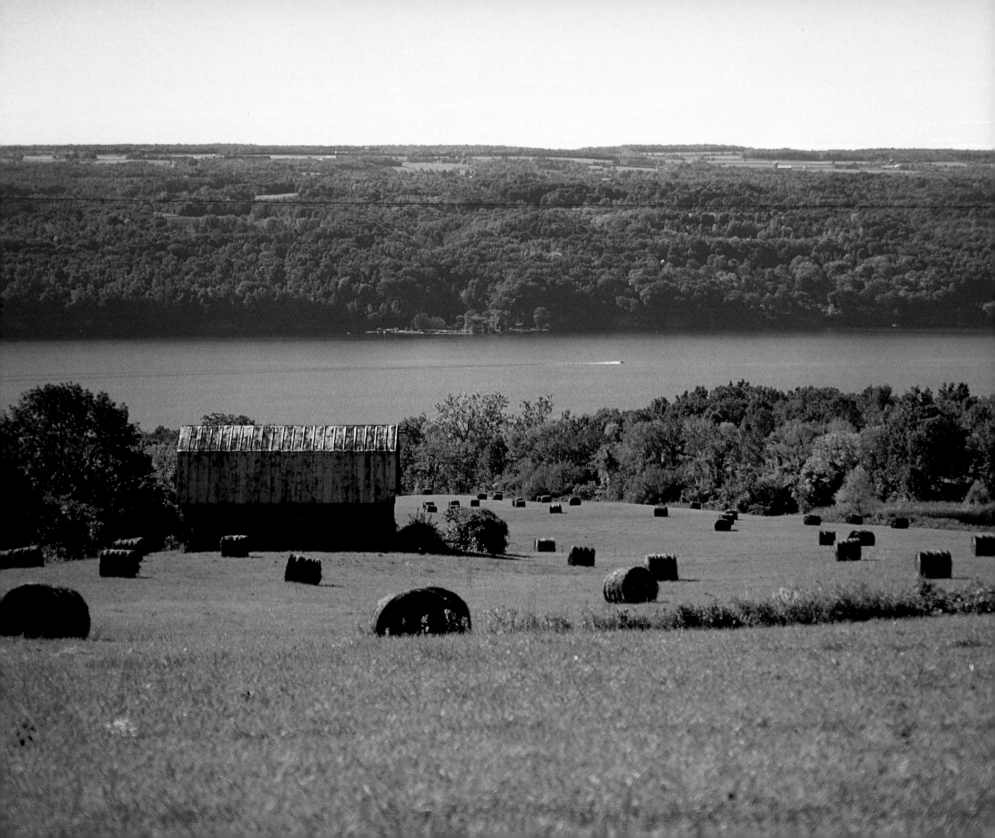

Wells College, Aurora

To capture the colorful horizon and the raft
of geese, it was necessary to play hide and seek
with the sun.

Howland Mill, Union Springs

The mill pond offers a safe and tranquil respite for
ducks and geese after a day of foraging.

MARK TWAIN'S STUDY, ELMIRA COLLEGE

Samuel L. Clemens spent more than 20 summers in Elmira, where he wrote Huckleberry Finn *and* Tom Sawyer *in this study.*

HAY BALES

*A photographic jewel I discovered along the roadside
from Elmira to Ithaca.*

CIVIL WAR REENACTORS

Pioneer Cemetery, Elbridge

RENAISSANCE FAIRE, STERLING

A season of color and celebration.

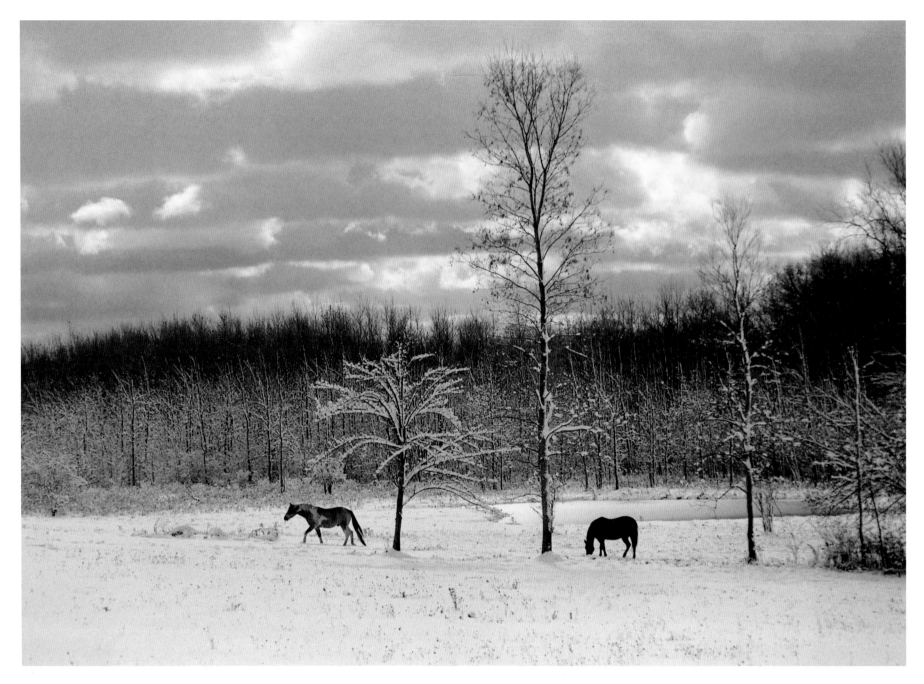

WINTER GRAZING, SENNETT

Winter in upstate New York often arrives as early as October and lingers into late April or May.

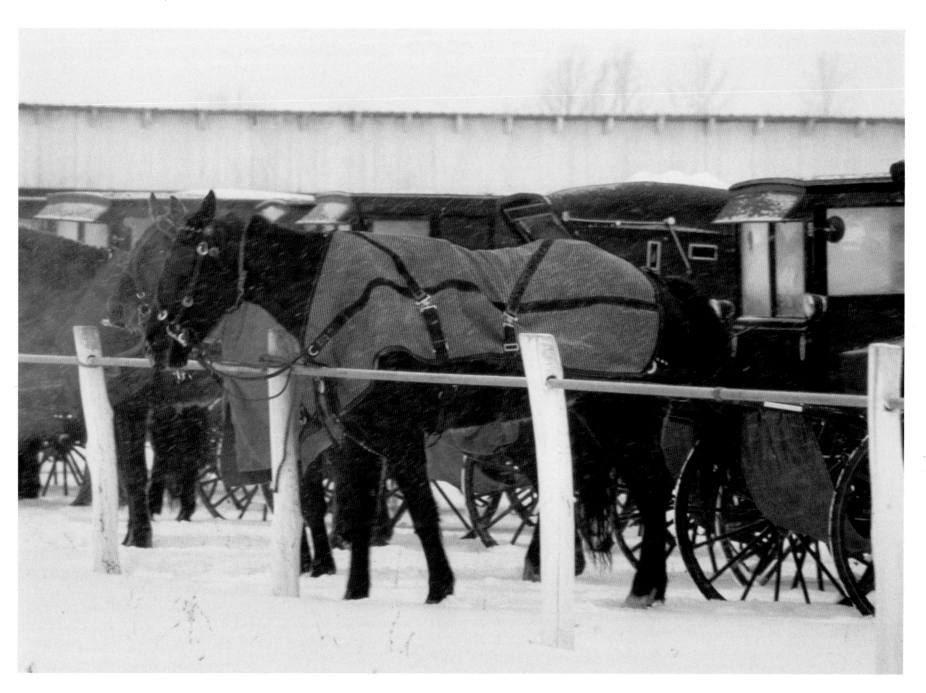

RED BLANKET, MILO

The sight of a Mennonite wagon on a country road is a colorful reminder of the history and diversity of the Finger Lakes region.

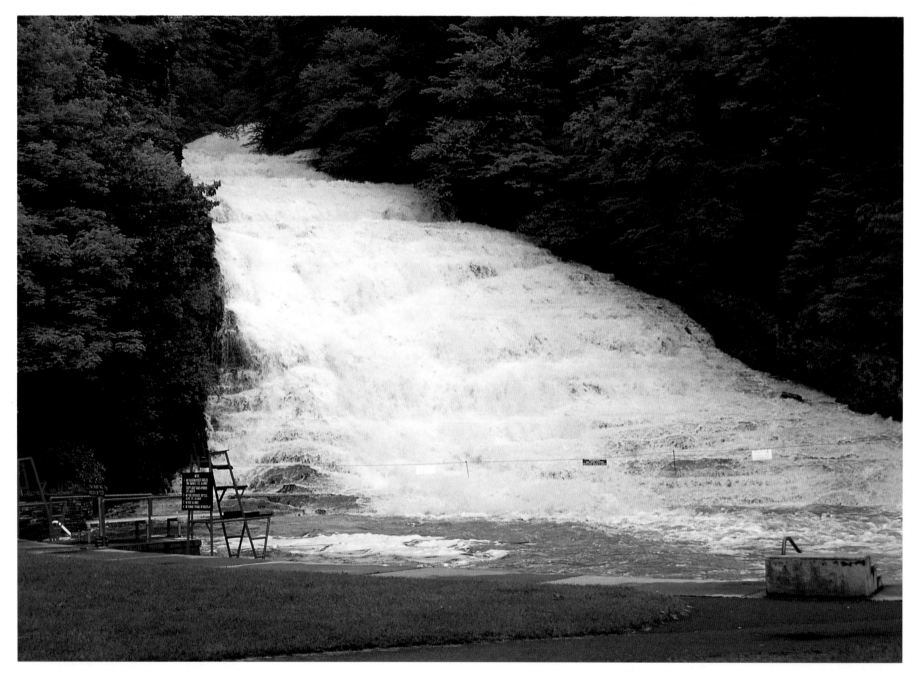

BUTTERMILK FALLS, ITHACA

*No swimming allowed as the spring runoff
cascades over the 500-foot drop.*

CHEQUAGA FALLS AT MONTOUR FALLS

One of the most spectacular sights in the Finger Lakes. A sketch of the falls, on display in the Louvre, was made circa 1820 by Louis Philippe (King of France, 1830-1848) on a tour of America.

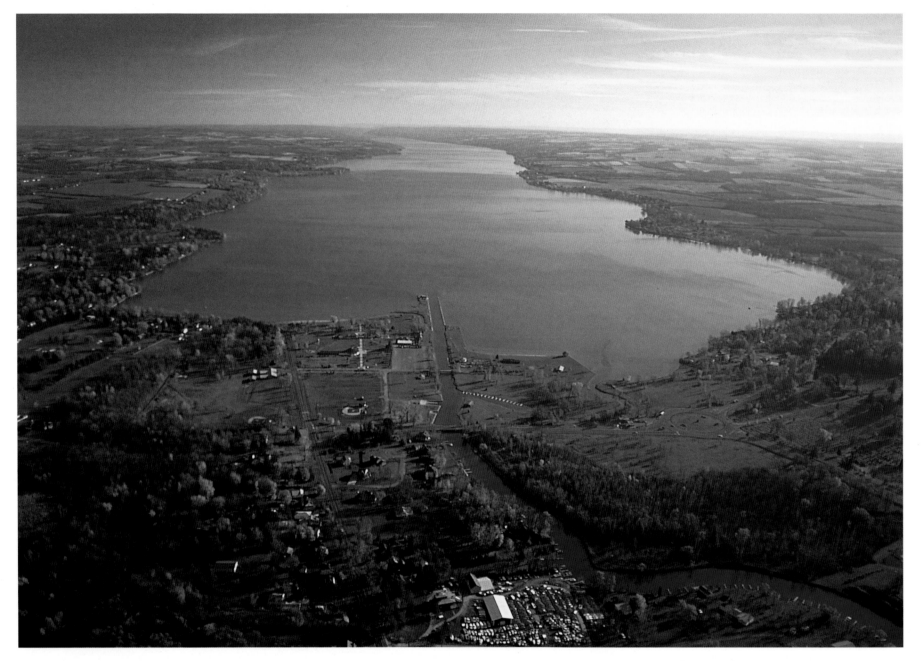

OWASCO LAKE

Eleven miles long, 177 feet deep.
The city of Auburn was settled a mile downstream to take
advantage of water power from the outlet for its first industry.

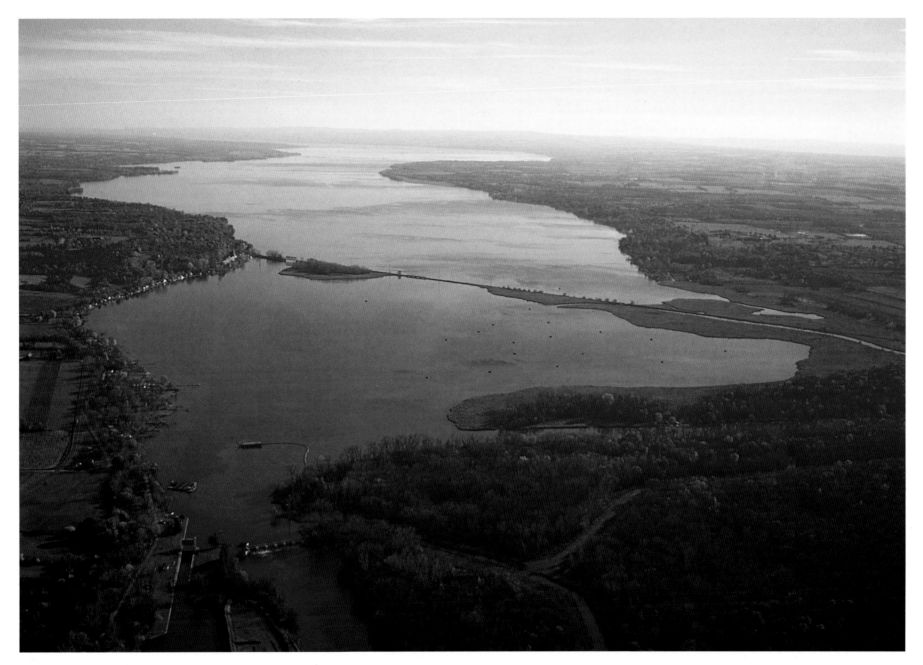

Cayuga Lake

Forty miles long, 435 feet deep.
The Seneca-Cayuga spur of the Erie Canal winds through
the Montezuma wetlands toward Seneca Lake.

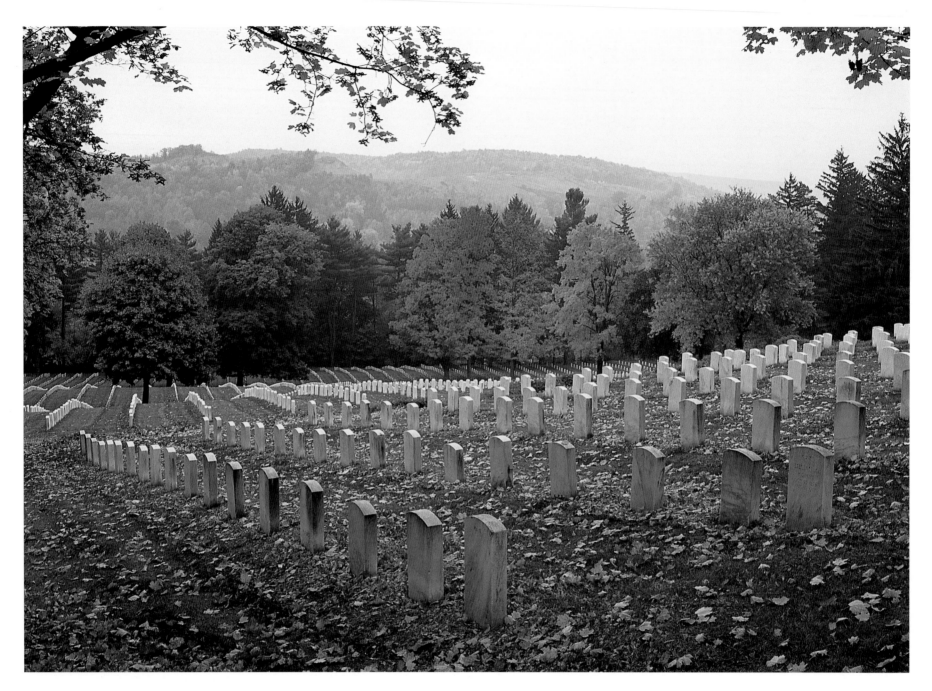

NATIONAL CEMETERY, BATH

The sign at the cemetery entrance reads:
"THE PRICE OF FREEDOM IS VISIBLE HERE"

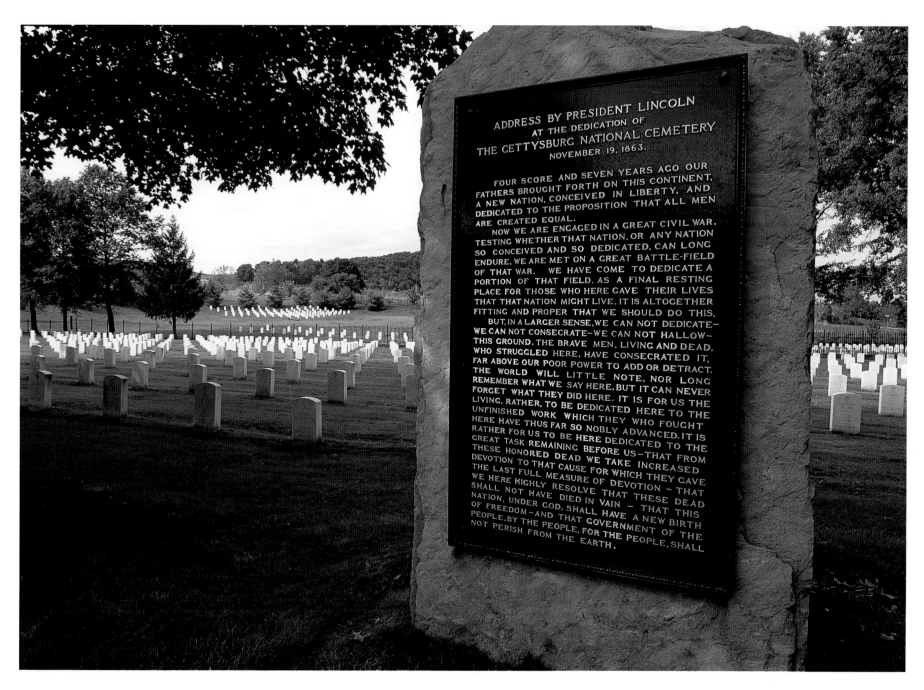

ADDRESS BY PRESIDENT LINCOLN
AT THE DEDICATION OF
THE GETTYSBURG NATIONAL CEMETERY
NOVEMBER 19, 1863.

FOUR SCORE AND SEVEN YEARS AGO OUR
FATHERS BROUGHT FORTH ON THIS CONTINENT,
A NEW NATION, CONCEIVED IN LIBERTY, AND
DEDICATED TO THE PROPOSITION THAT ALL MEN
ARE CREATED EQUAL.
NOW WE ARE ENGAGED IN A GREAT CIVIL WAR,
TESTING WHETHER THAT NATION, OR ANY NATION
SO CONCEIVED AND SO DEDICATED, CAN LONG
ENDURE. WE ARE MET ON A GREAT BATTLE-FIELD
OF THAT WAR. WE HAVE COME TO DEDICATE A
PORTION OF THAT FIELD, AS A FINAL RESTING
PLACE FOR THOSE WHO HERE GAVE THEIR LIVES
THAT THAT NATION MIGHT LIVE. IT IS ALTOGETHER
FITTING AND PROPER THAT WE SHOULD DO THIS.
BUT, IN A LARGER SENSE, WE CAN NOT DEDICATE—
WE CAN NOT CONSECRATE—WE CAN NOT HALLOW—
THIS GROUND. THE BRAVE MEN, LIVING AND DEAD,
WHO STRUGGLED HERE, HAVE CONSECRATED IT,
FAR ABOVE OUR POOR POWER TO ADD OR DETRACT.
THE WORLD WILL LITTLE NOTE, NOR LONG
REMEMBER WHAT WE SAY HERE, BUT IT CAN NEVER
FORGET WHAT THEY DID HERE. IT IS FOR US THE
LIVING, RATHER, TO BE DEDICATED HERE TO THE
UNFINISHED WORK WHICH THEY WHO FOUGHT
HERE HAVE THUS FAR SO NOBLY ADVANCED. IT IS
RATHER FOR US TO BE HERE DEDICATED TO THE
GREAT TASK REMAINING BEFORE US—THAT FROM
THESE HONORED DEAD WE TAKE INCREASED
DEVOTION TO THAT CAUSE FOR WHICH THEY GAVE
THE LAST FULL MEASURE OF DEVOTION — THAT
WE HERE HIGHLY RESOLVE THAT THESE DEAD
SHALL NOT HAVE DIED IN VAIN — THAT THIS
NATION, UNDER GOD, SHALL HAVE A NEW BIRTH
OF FREEDOM—AND THAT GOVERNMENT OF THE
PEOPLE, BY THE PEOPLE, FOR THE PEOPLE, SHALL
NOT PERISH FROM THE EARTH.

NATIONAL CEMETERY, ELMIRA

*Over 2,000 Confederate soldiers
are buried here.*

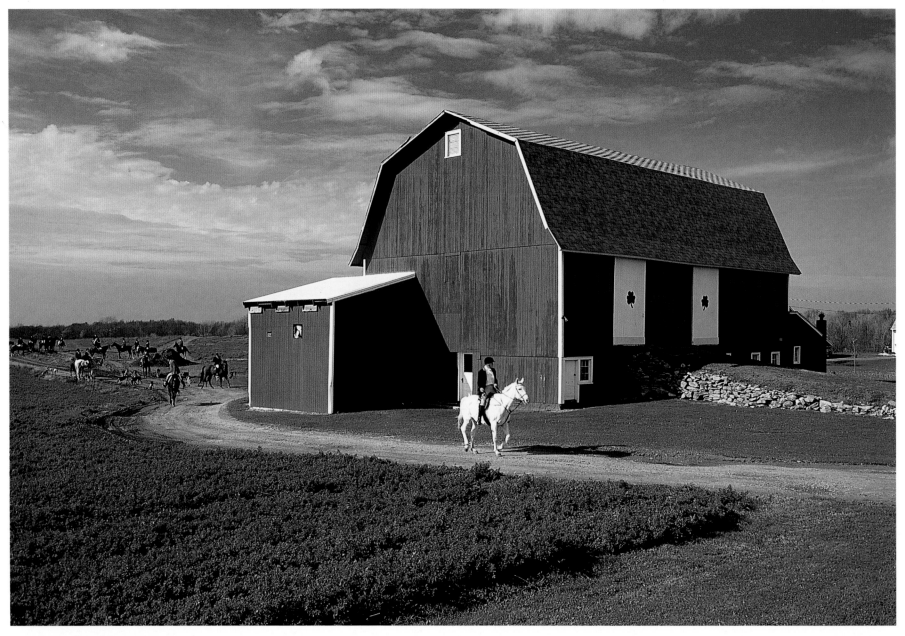

THE DELANEY FARM

Elbridge

SUNDAY MORNING HUNT

Elbridge

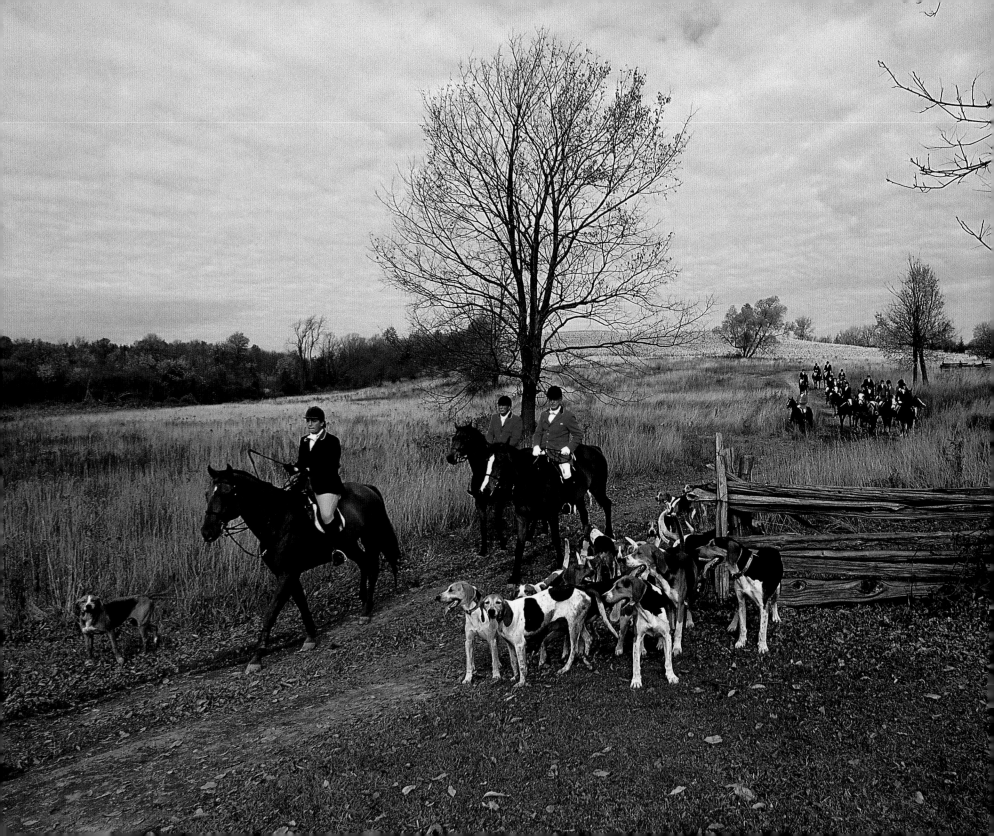

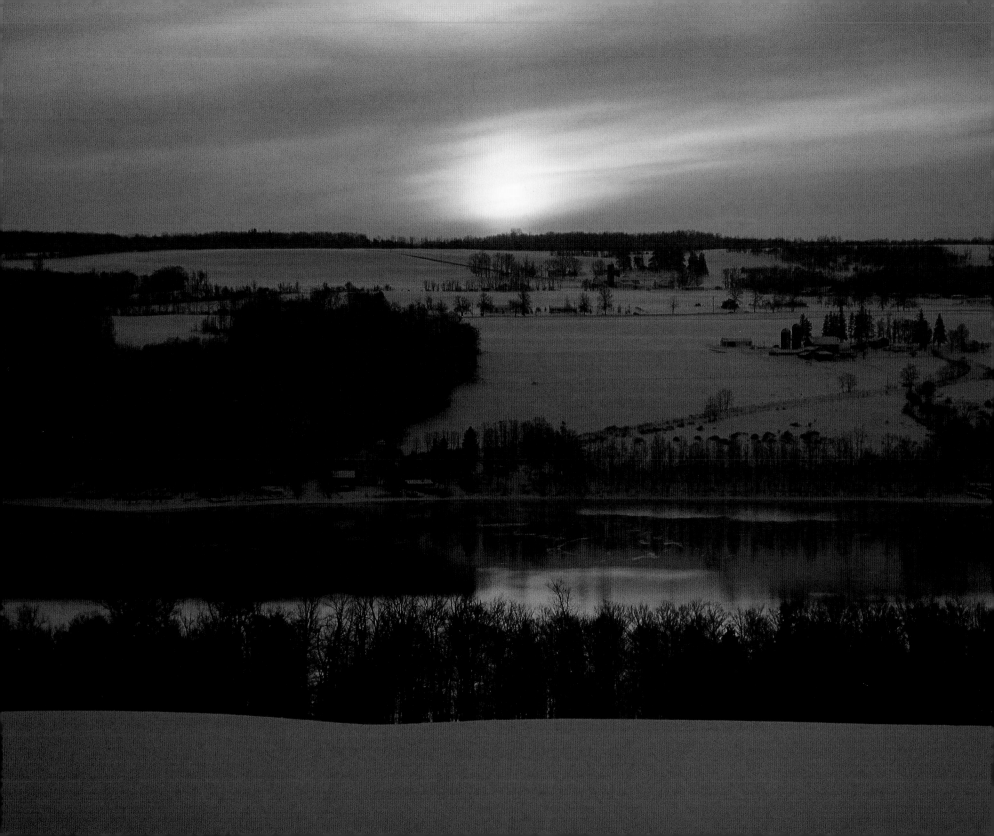

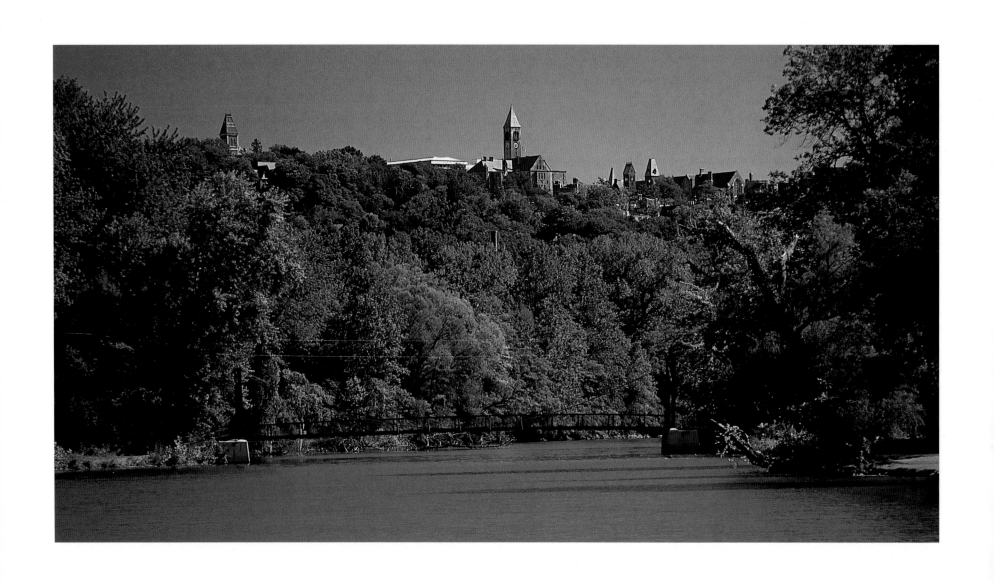

STEWART PARK, ITHACA

View of Cornell University's McGraw Tower.

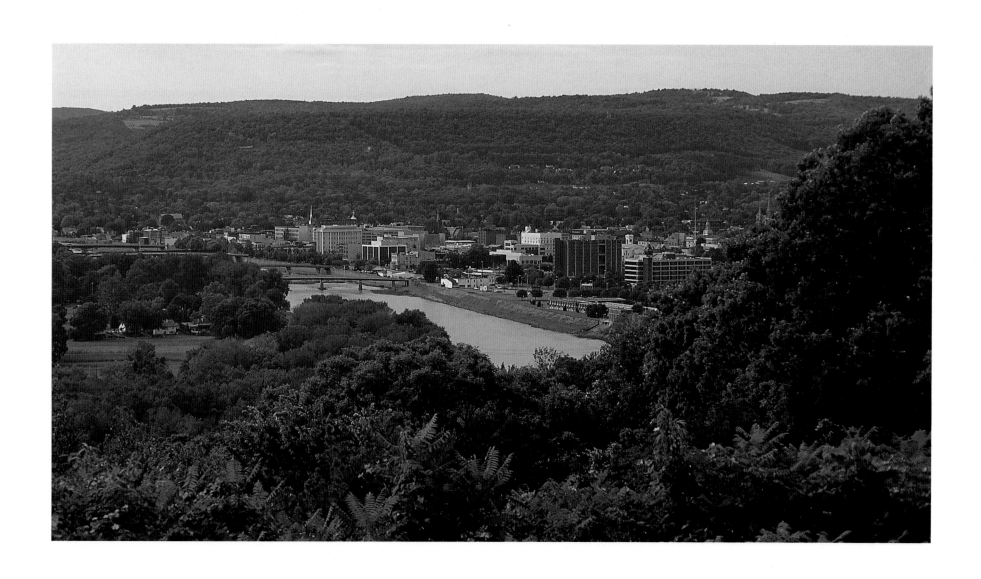

CITY OF ELMIRA

On the Chemung River

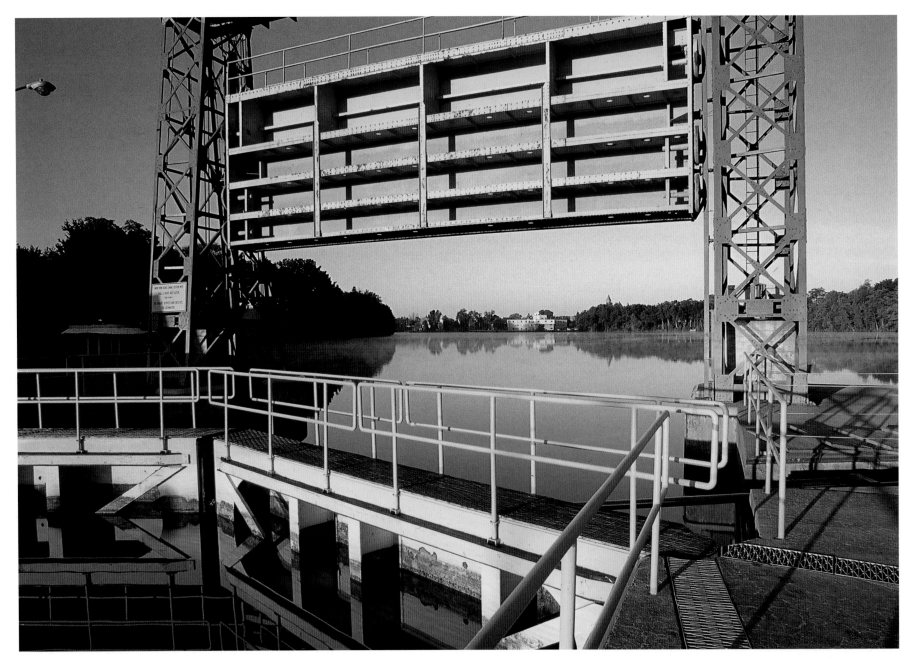

SENECA - CAYUGA LOCK, SENECA FALLS

The New York State Canal System connects hundreds of miles of
lakes and rivers from one end of the state to the other, linking the
Great Lakes with the Hudson River and five waterways in Canada.

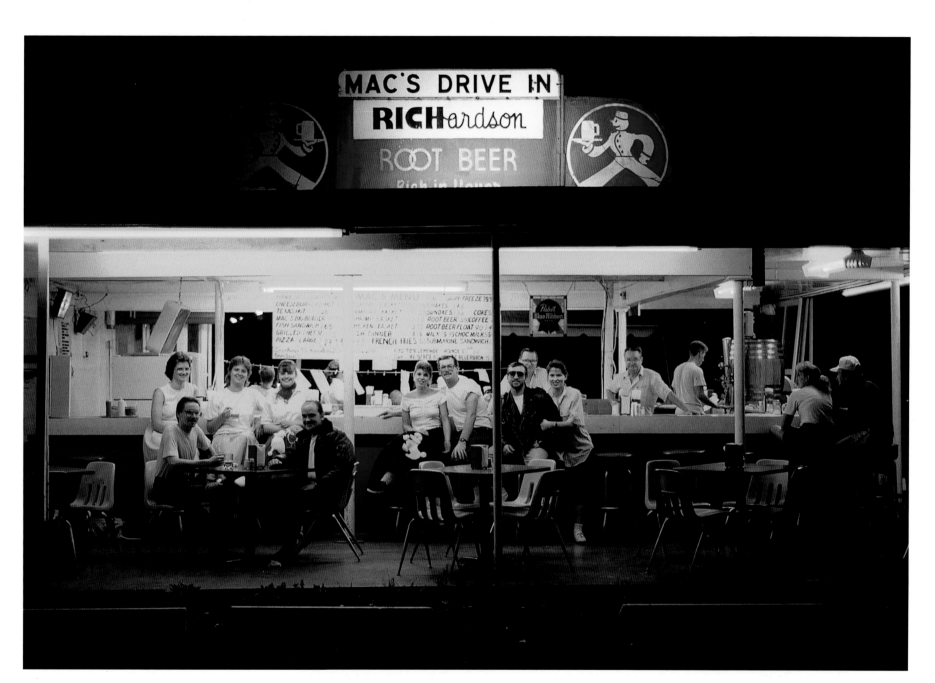

WAITING FOR ELVIS

Mac's Drive-in, Waterloo
A 1950's reunion in progress.

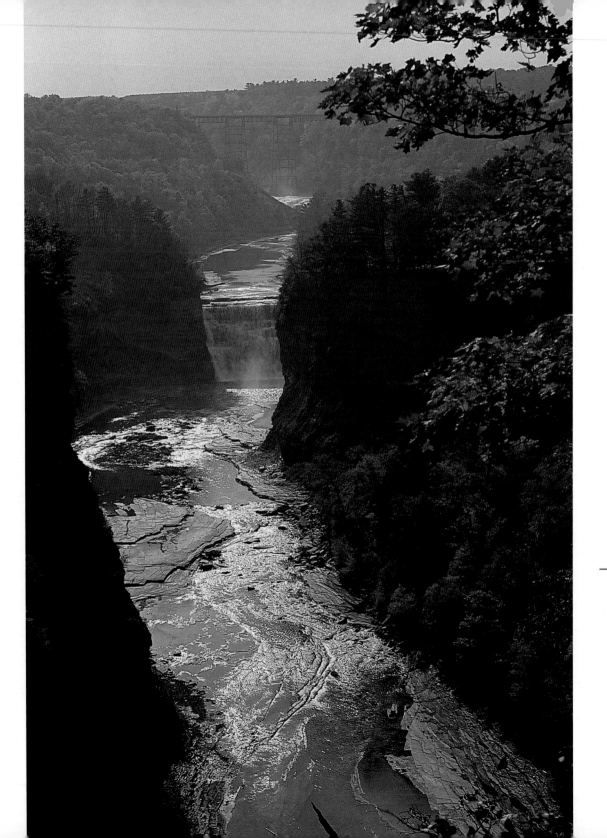

INSPIRATION POINT

Letchworth State Park

"God wrought for us this scene beyond compare,
but one man's loving hand protected it.
And gave it to his fellow men to share.
—Sara Evans Letchworth

Hudson River School artist, Thomas Cole's
1839 oil painting of Inspiration Point
was given as a gift to William H. Seward
for his contribution to the expansion of the
Erie Canal in the region.
The painting is displayed in the photograph
of Seward's Auburn home on page 62.

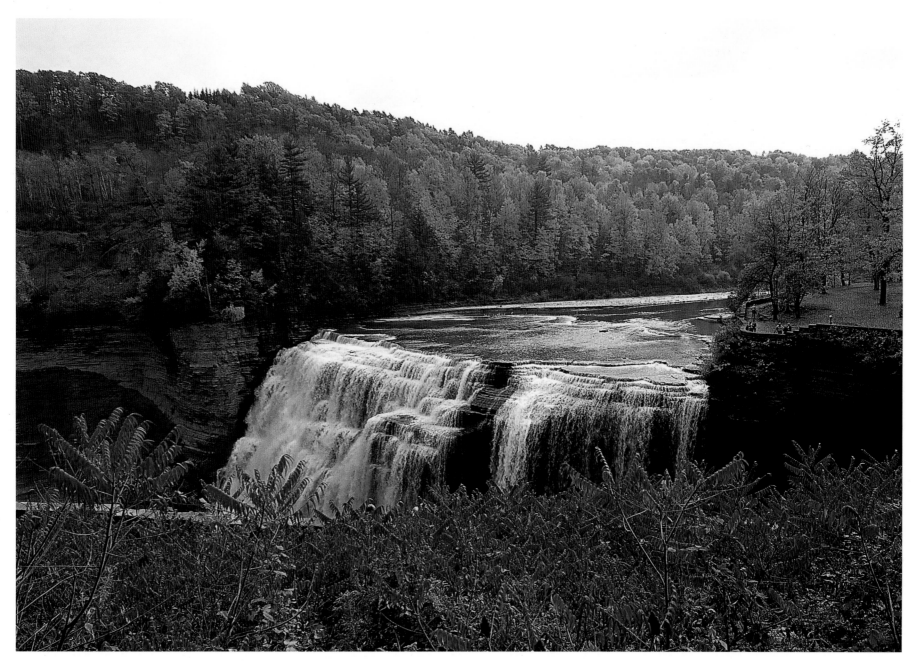

MIDDLE FALLS

*Letchworth State Park's 17 mile, 600 foot deep
gorge at Letchworth State Park has been referred
to as the "Grand Canyon of the East."*

SENECA LAKE

Thirty-six miles long, 632 feet deep.
Ancient Iroquois tribesmen believed the Finger Lakes were shaped by
the imprint of the Creator's fingers as He blessed this favored land.

WANETA AND LAMOKA LAKES

These smaller lakes, within the Finger Lakes, border the site of ancient Indian villages, the oldest such sites in New York State.

33

ESPERANZA ROAD, BLUFF POINT

One of the most popular views of Keuka Lake in any season. The Finger Lakes, with vineyards dating back to 1829 and wineries to 1860, is one of America's most historic wine regions.

Vineyards, Italy Hill along Keuka Lake

Timber from this area was used to construct the U.S. battleship
Monitor in the Civil War. The Monitor and the Merrimack fought
the first battle between ironclad ships, revolutionizing naval warfare.

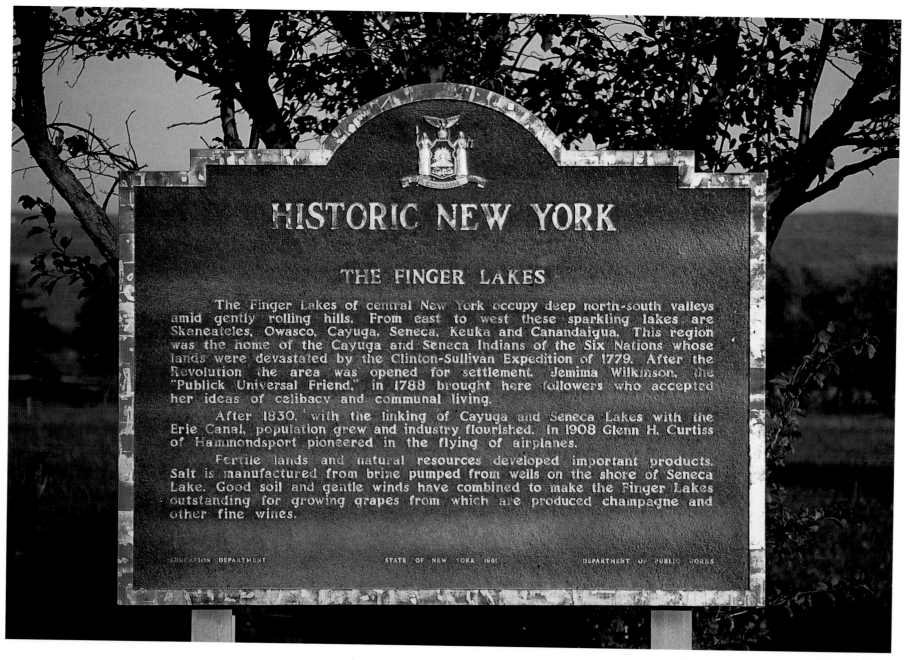

HISTORIC MARKER

West side of Seneca Lake

36

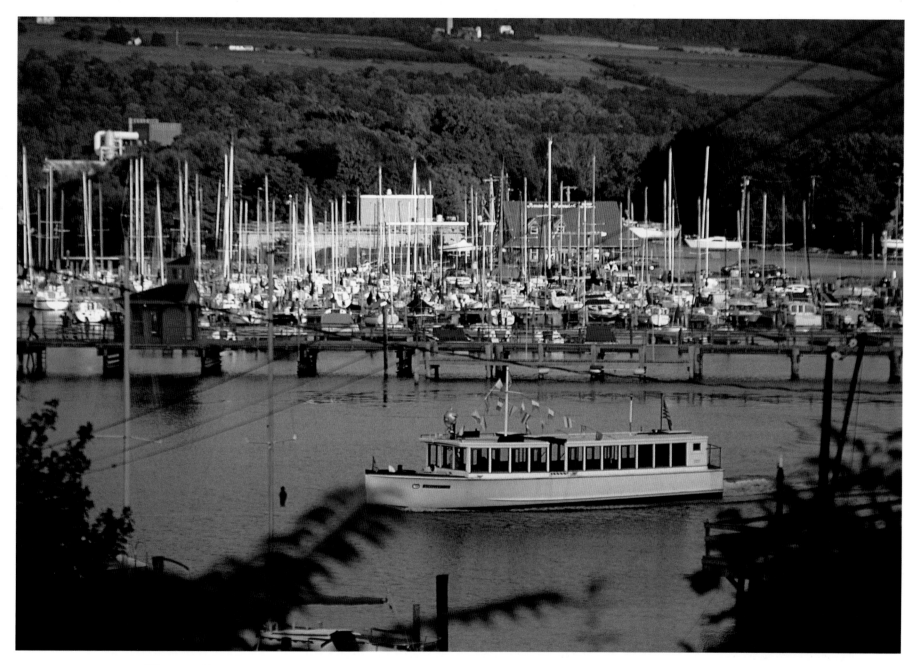

WATKINS GLEN

As I prepared to shoot the golden reflections,
the boat cruised into the frame.
The Glen is known as the home of American road racing.

37

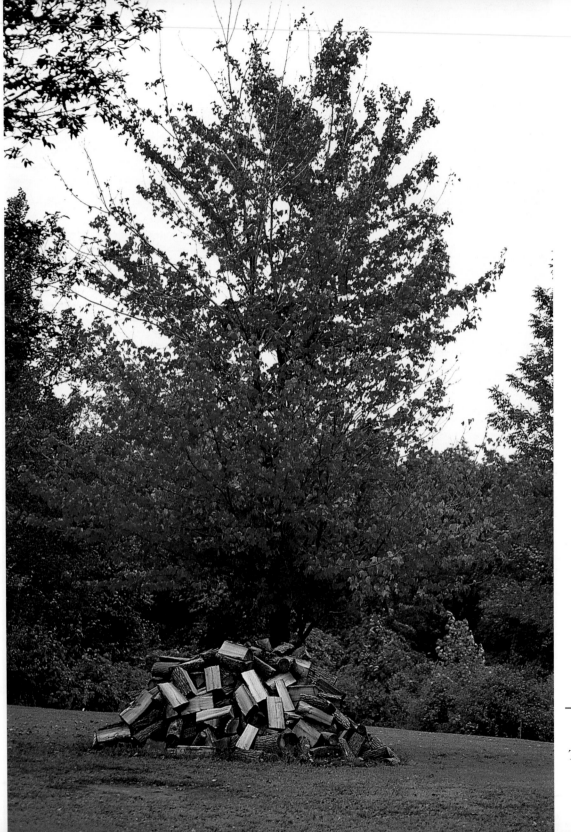

WOOD HARVEST, WAYNE COUNTY

*Red maple, sugar maple, yellow birch and aspen
blanket the Finger Lakes autumn color palette.
The spectrum of bright fall colors in the forests of the
northeast United States is unique.*

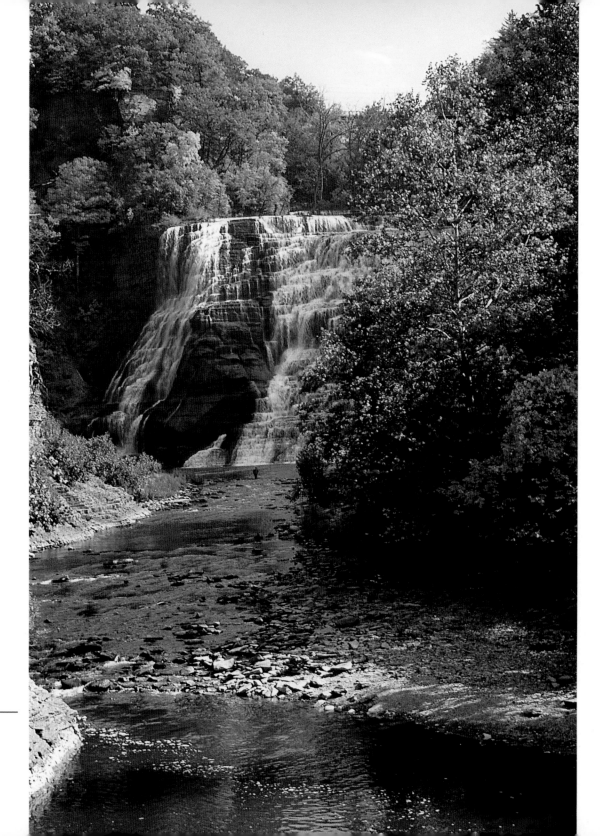

ITHACA FALLS

*The gorges of Ithaca — Fall Creek, Cascadilla,
Six Mile and Butternut Creek — abound
with spectacular waterfalls.*

39

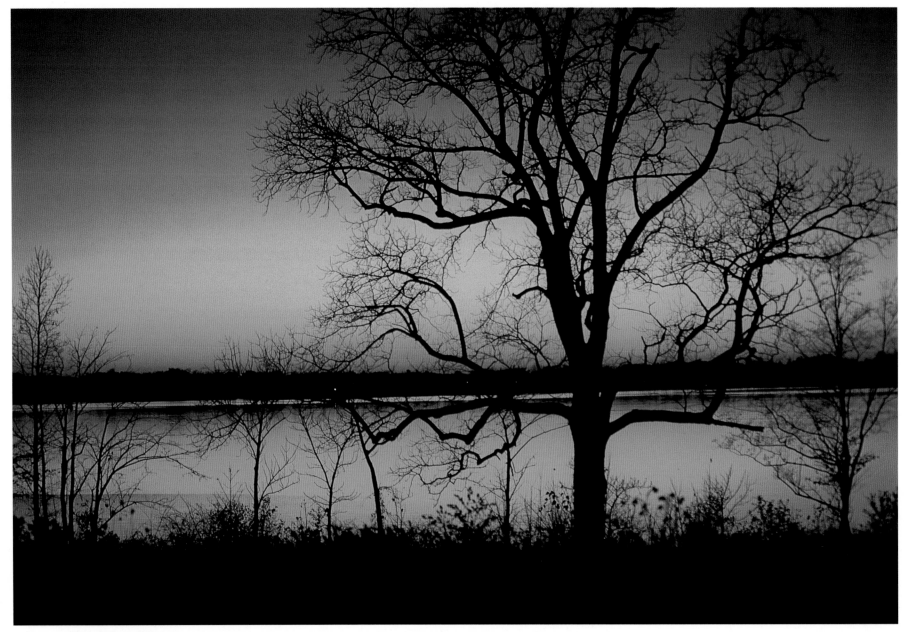

MARTIN POINT

Owasco Lake
The sun had set and we were heading for
home when the afterglow lit up the sky.

PUMPKIN HARVEST

Rose Hill, Onondaga County

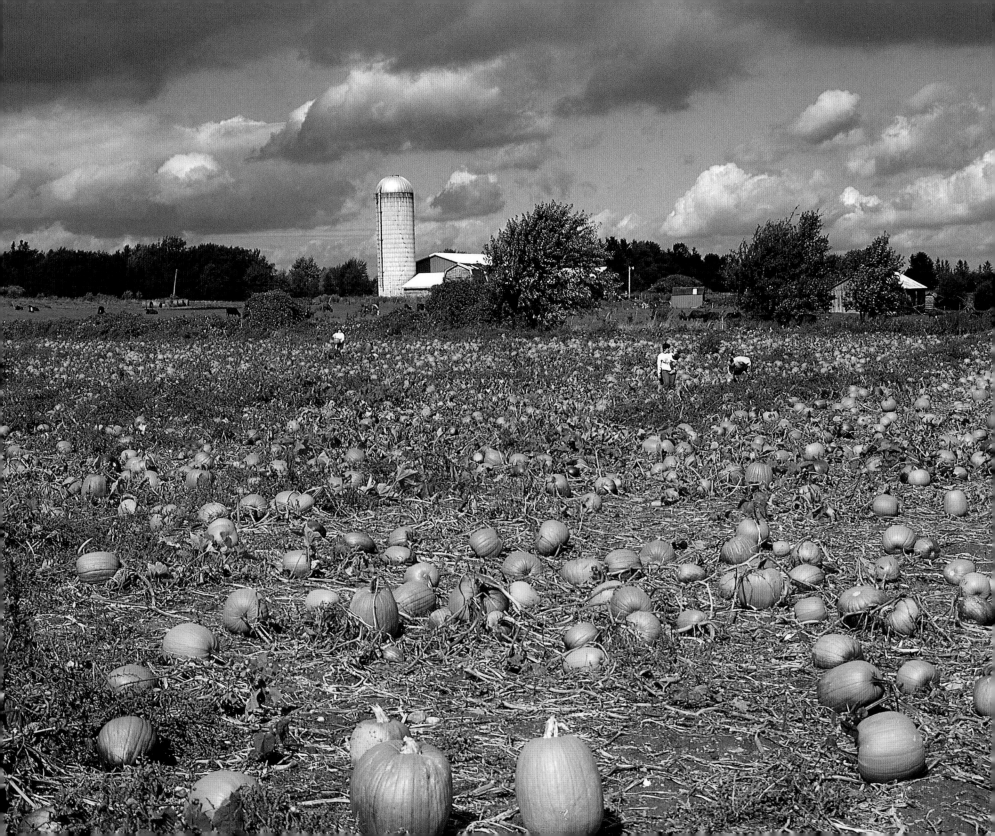

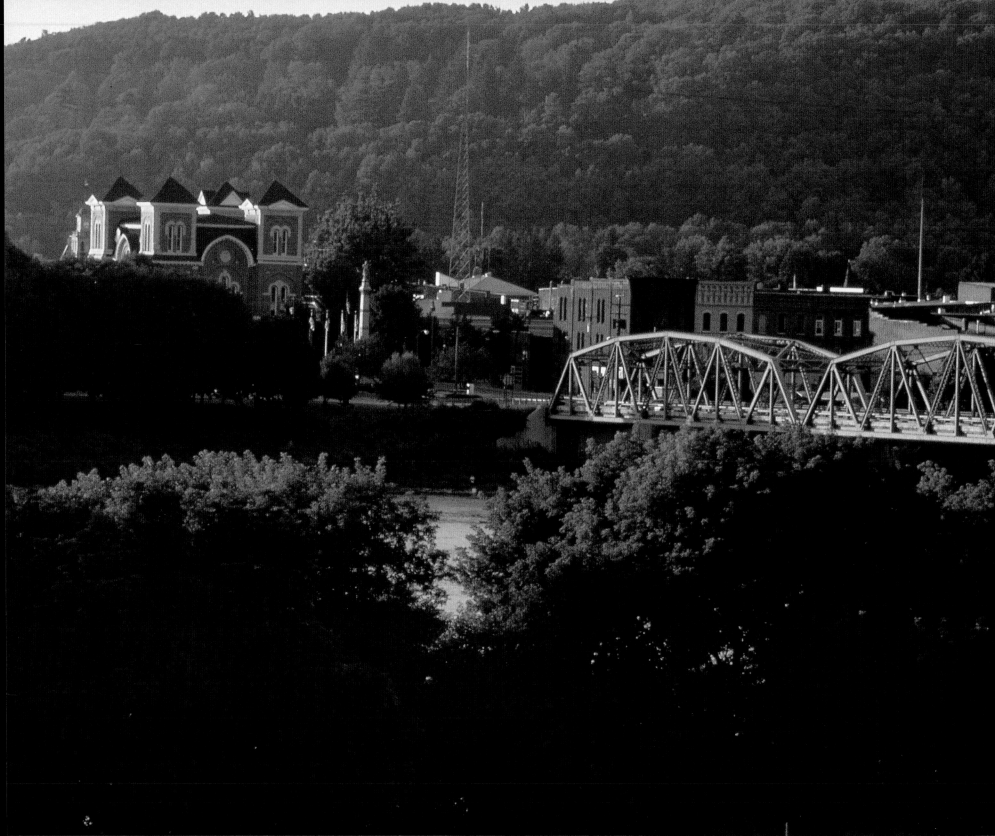

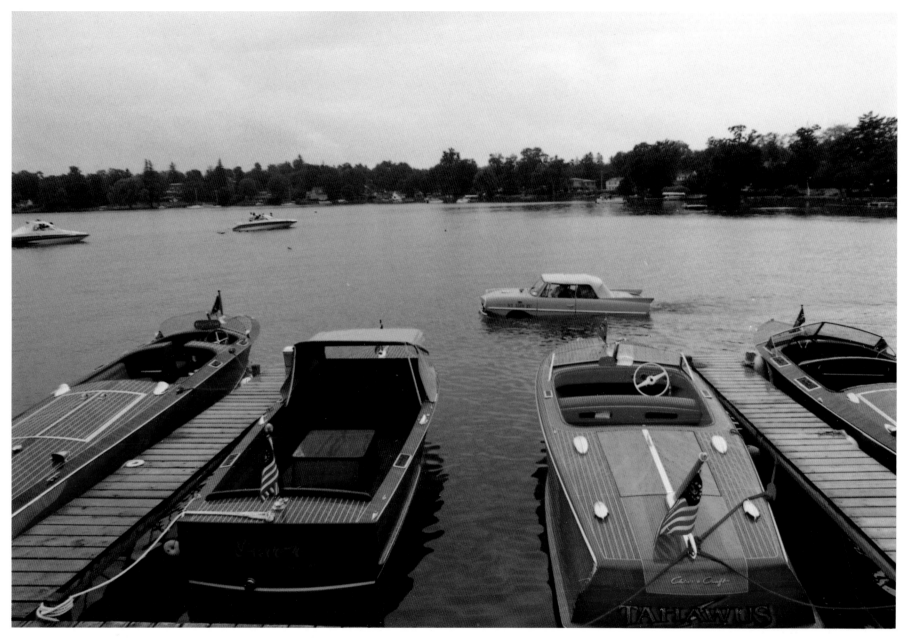

THE VILLAGE OF OWEGO

*General Robert wrote his Rules of Order at his home
on Front Street here. Nearby lived Belva Lockwood,
the first woman to run for U.S. President.*

ANTIQUE BOAT SHOW

*Skaneateles Lake
Parking is tough at times!*

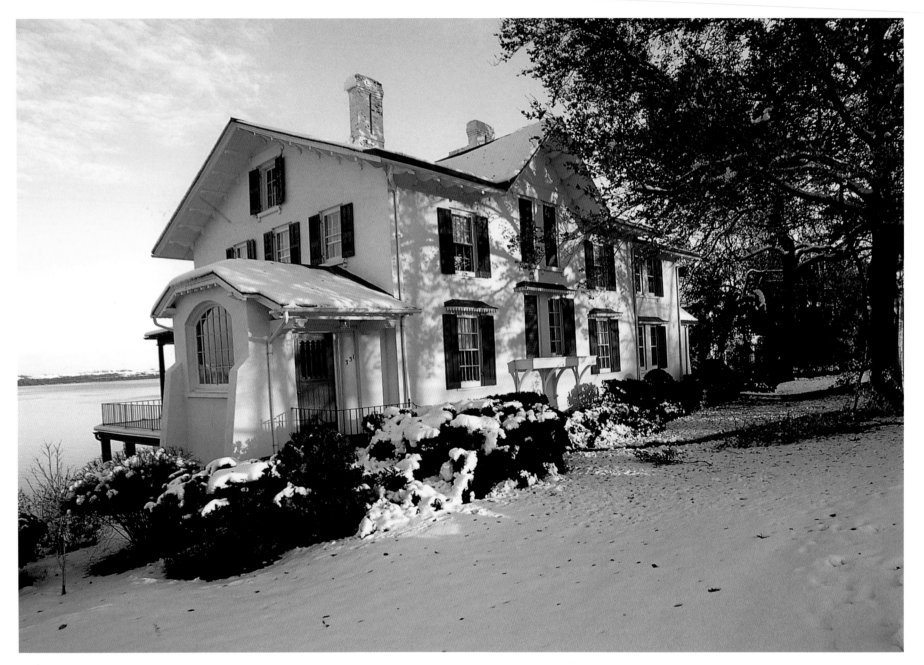

HOUSE ON SENECA LAKE

Geneva, near Hobart & William Smith College

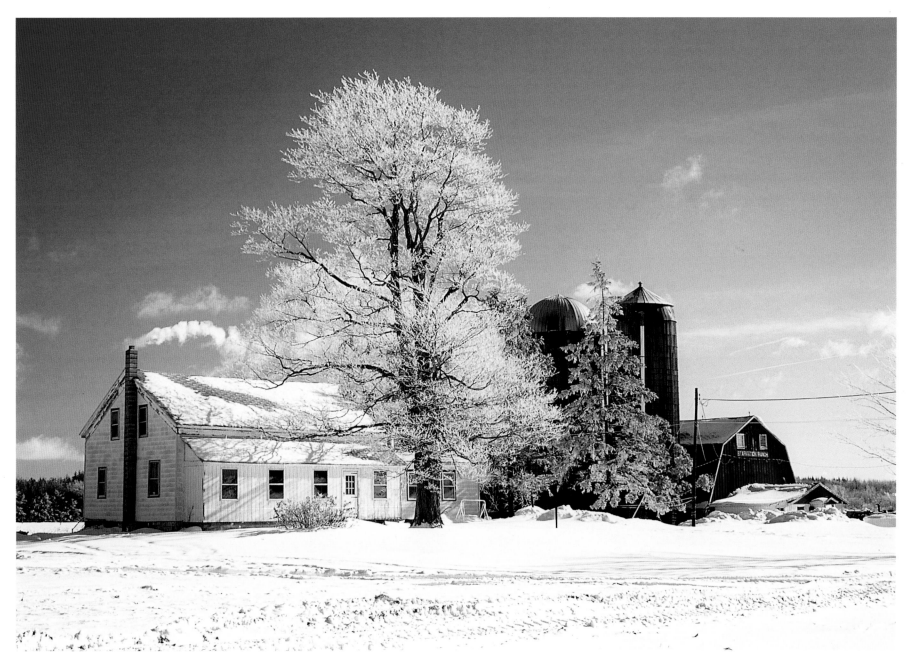

STARVATION RANCH

Sempronius, Cayuga County
Winter in upstate New York can be severe, but intermittent thaws and
bursts of sunshine often transform the landscape into glistening color.

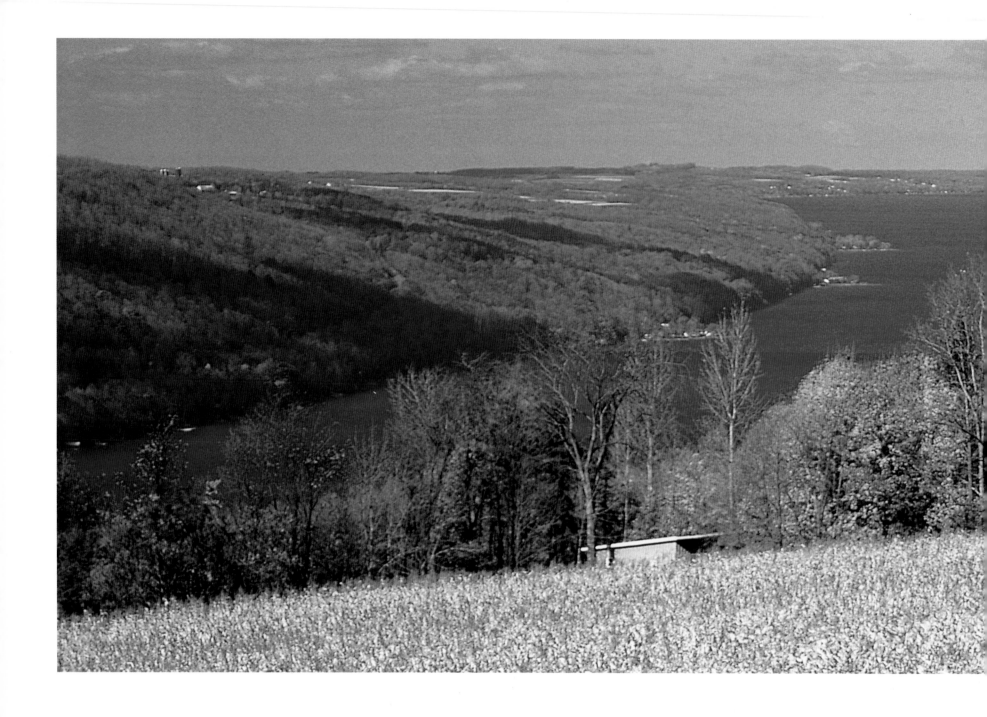

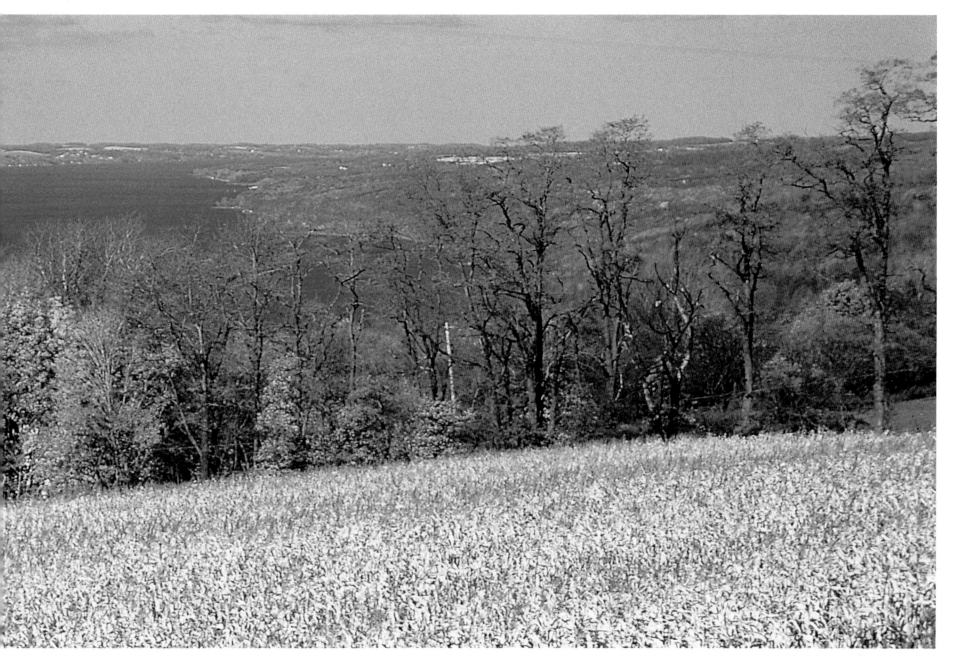

"The Homecoming View" Skaneateles Lake

*The road home from Interstate 81 winds through Cortland and Homer to
Scott, where it rises and expands to include this magnificent panorama
of the lake. At this point, most of us feel we are already home.*

47

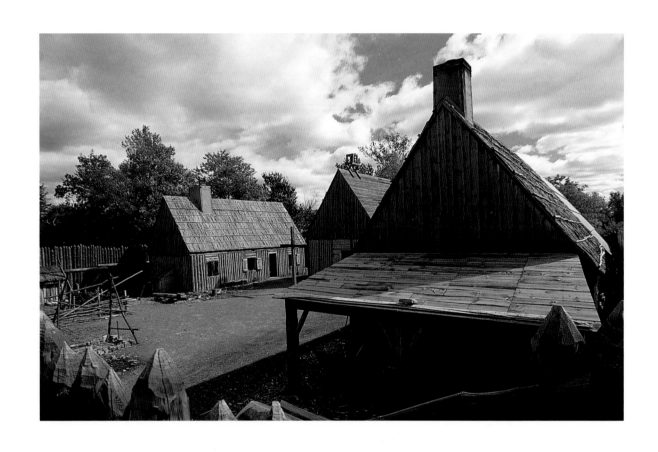

ST. MARIE AMONG THE IROQUOIS, SYRACUSE

*The lifestyle of 17th Century French explorers
and Iroquois natives is recreated here.*

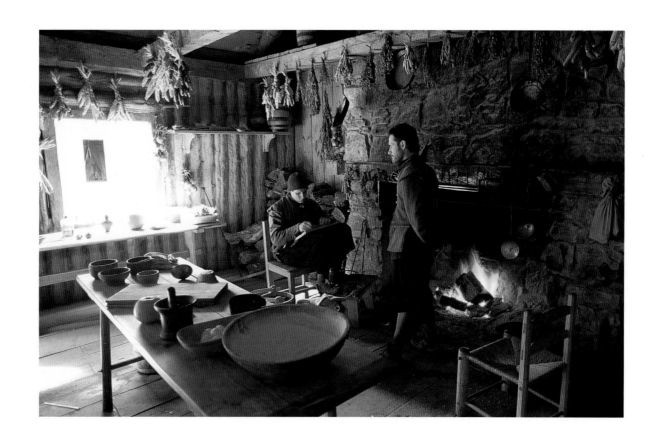

St. Marie Among the Iroquois, Syracuse
Father LeMoyne visited the salt springs at Onondaga Lake in 1654.
The following year two more Jesuits arrived and established a mission
which closed soon after because of Indian hostility.

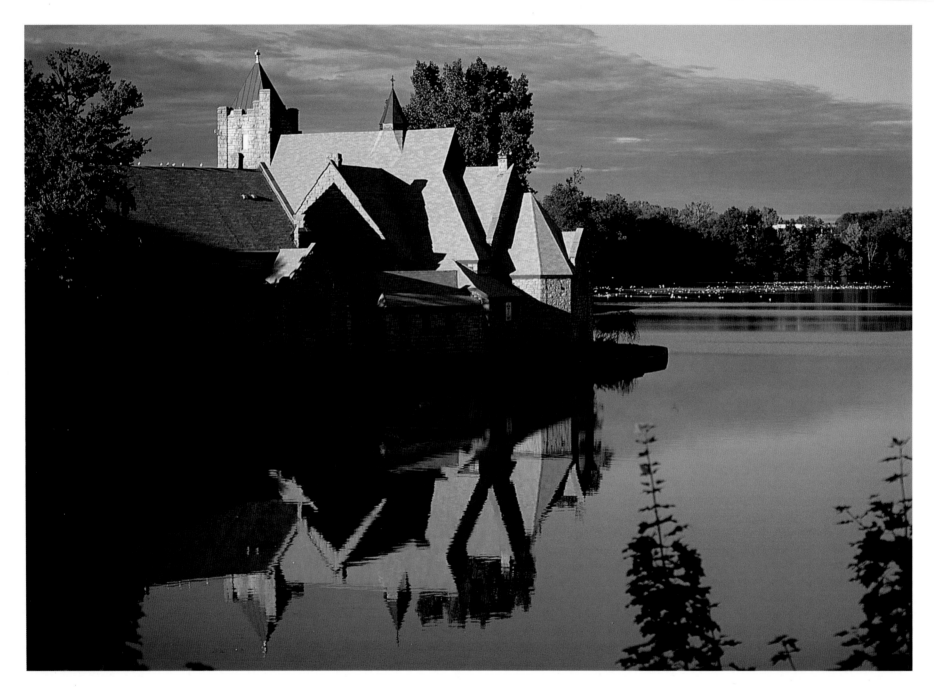

TRINITY EPISCOPAL CHURCH

Van Cleef Lake, Seneca Falls
When traveling through Seneca Falls, I always check out this view.

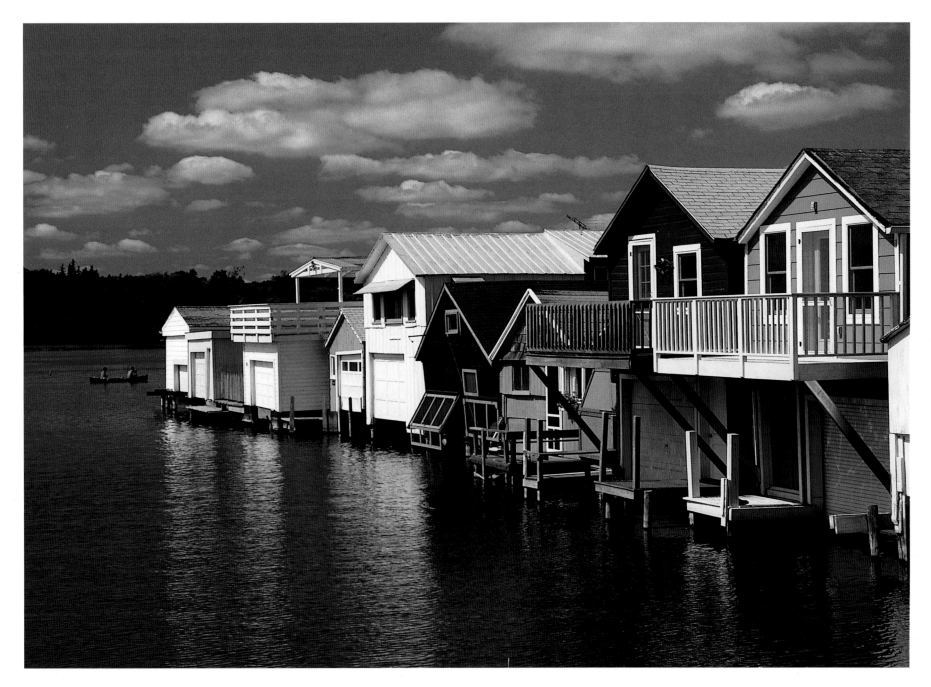

BOAT HOUSES, CANANDAIGUA LAKE

Built around 1850 and moved to their present site in 1887, these "Finger Piers" were built to accommodate railroad and steamboat traffic.

SOUTHWICK CEMETERY, JUNIUS

Seneca County
*It was late in the day when I first noticed the unusual shape of this tree
and decided to return at sunrise to photograph it.*

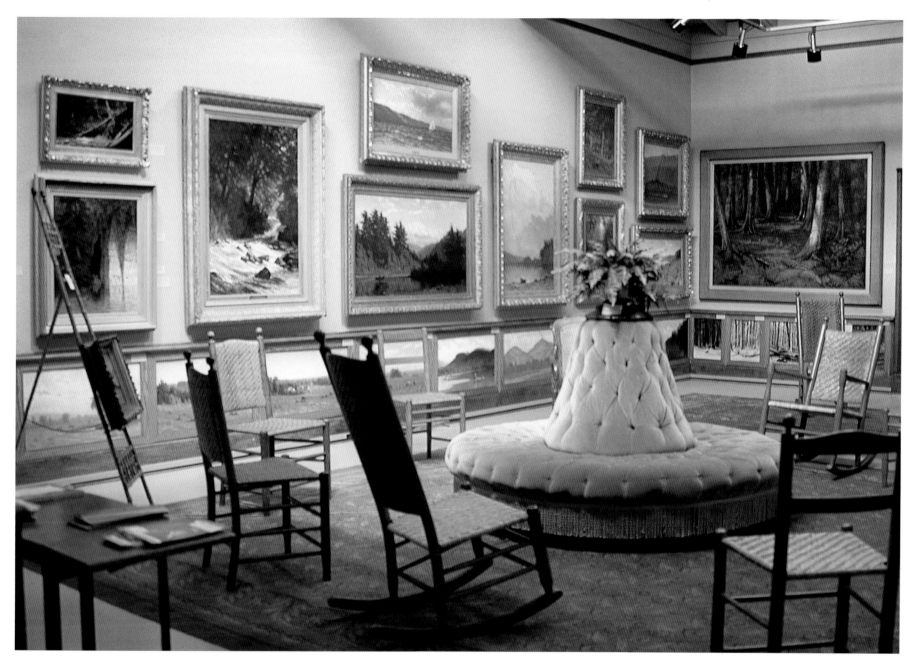

JOHN D. BARROW GALLERY, SKANEATELES

Influenced by the Hudson River School painters, Barrow is characterized as "one of central New York's most prolific artists." The gallery, opened in 1900, exhibits more than 300 Barrow oil paintings.

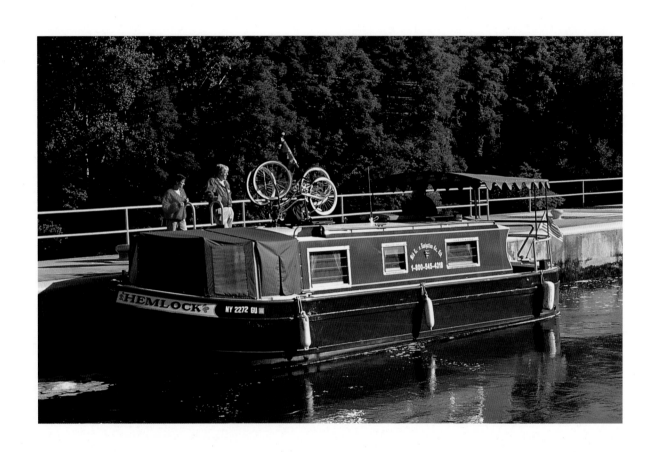

HEMLOCK GOING THROUGH THE LOCK AT SENECA FALLS

The Erie Canal was the most enterprising project
in 19th century America — revolutionizing transportation
between the Atlantic Ocean and the Great Lakes.

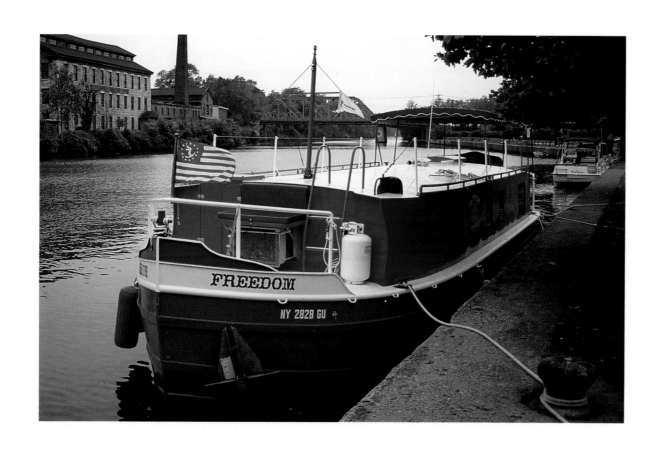

Freedom

A canal boat moored in Seneca Falls, the birthplace of the
Women's Rights movement. Memorial Day was first
commemorated in nearby Waterloo.

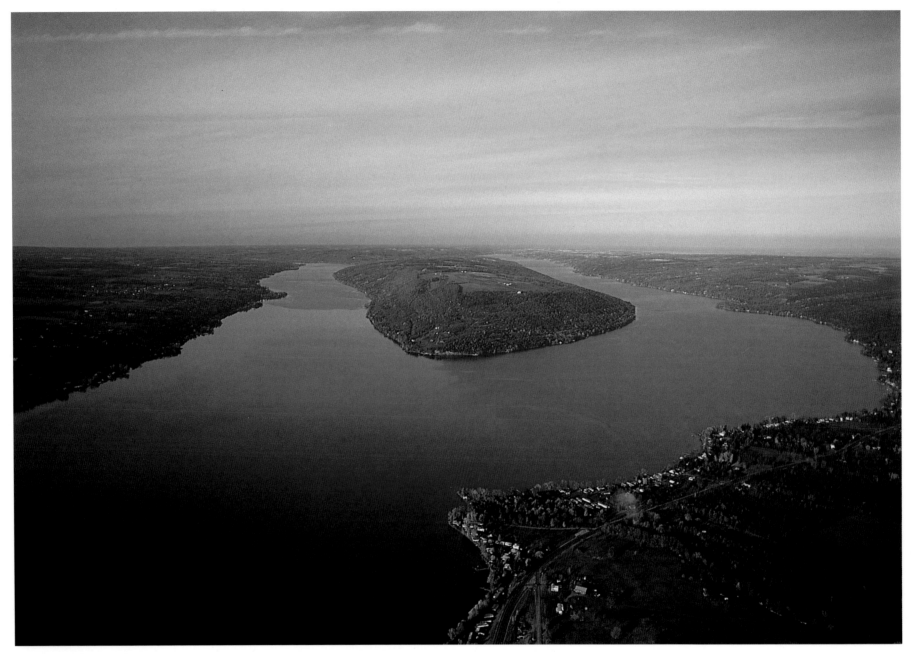

KEUKA LAKE

Twenty-two miles long, 187 feet deep.
The bluff impeded the glacial retreat to give Keuka
its unusual shape.

CANANDAIGUA LAKE

Sixteen miles long, 262 feet deep.
The first office for the sale of land directly to settlers in America was established
in Canandaigua, marking the beginning of settlement west of Seneca Lake.

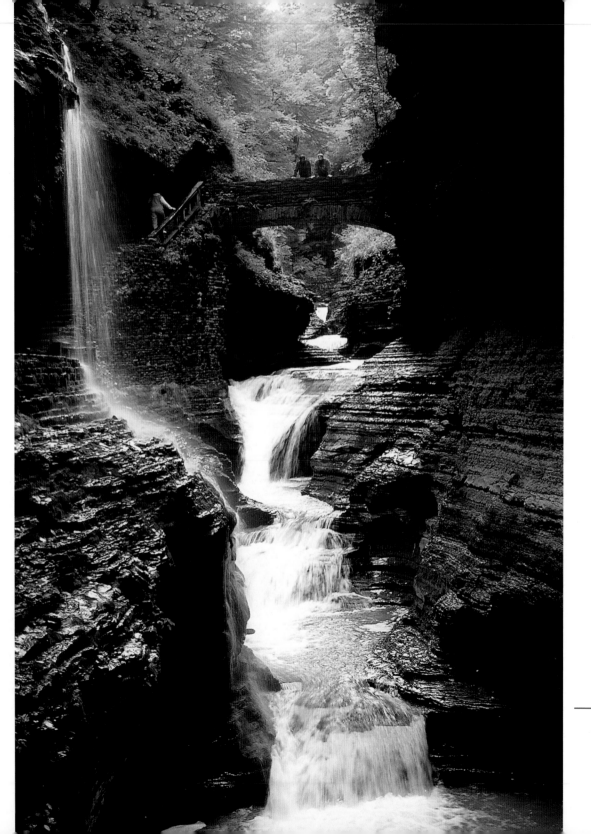

RAINBOW FALLS

Watkins Glen State Park
The rock layers in the gorge walls were formed
from sediments from an ancient sea that once
covered New York State.

58

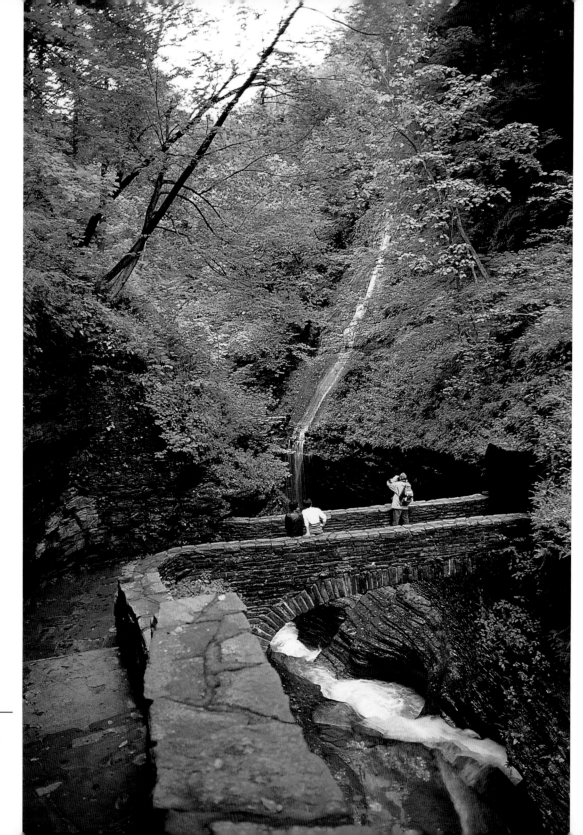

GLEN CREEK GORGE

Watkins Glen State Park
This "Eighth Wonder of the World" features two
miles of waterfalls, grottos and caverns. Once a
private resort, it opened to the public in 1863.

MARGARET R. CHASE GAZEBO, SKANEATELES

In his book, "Slim Fingers Beckon," the late
Finger Lakes journalist, Arch Merrill, wrote of Skaneateles:
"Few village main streets have such a setting."

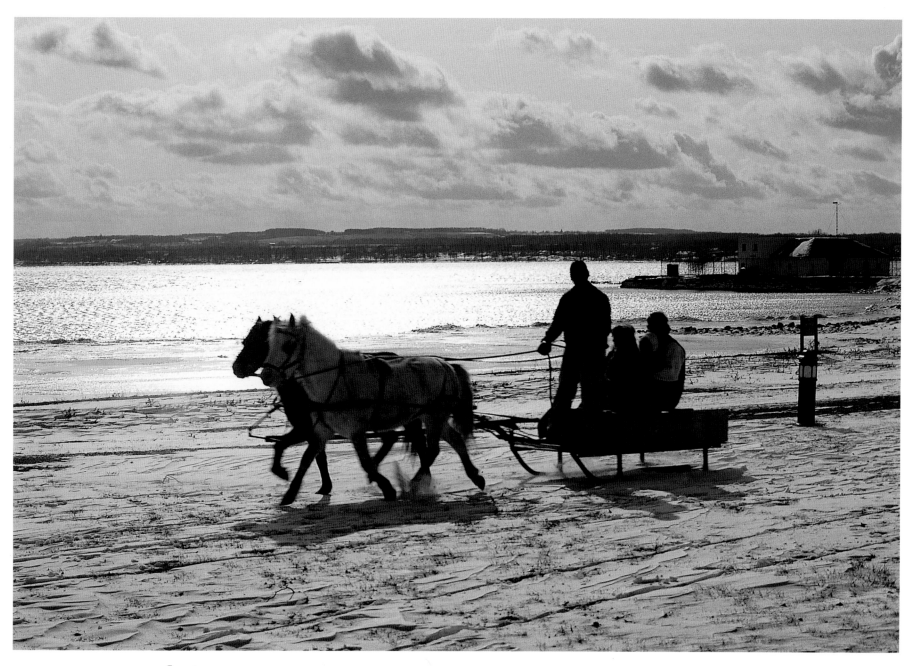

SLEIGHRIDE

Winterfest at Emerson Park on Owasco Lake.

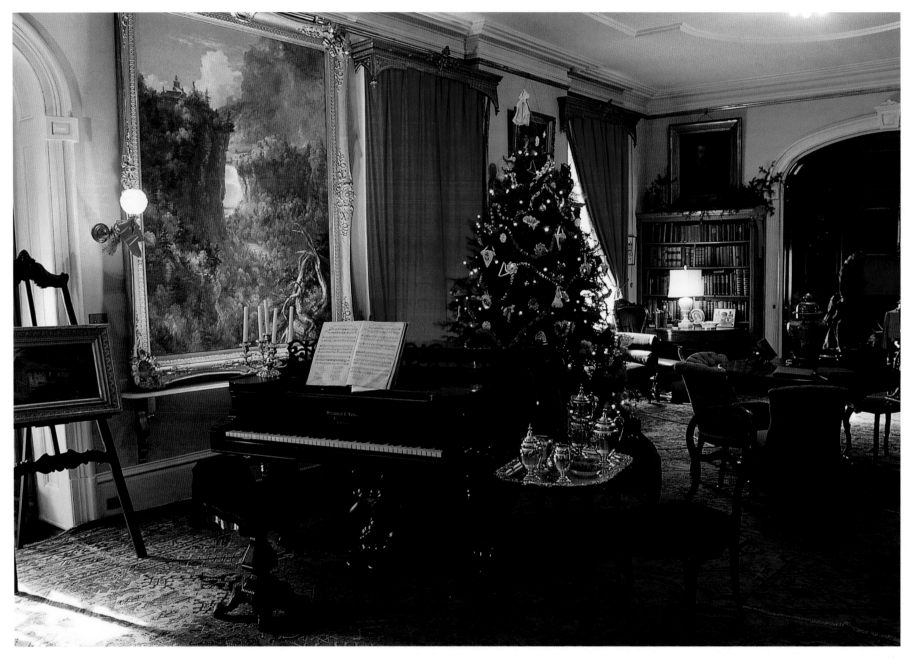

SEWARD HOUSE, AUBURN

William H. Seward was Secretary of State under President Abraham
Lincoln. Among the treasures displayed in his Victorian mansion is
Thomas Cole's painting of Inspiration Point in Letchworth State Park.

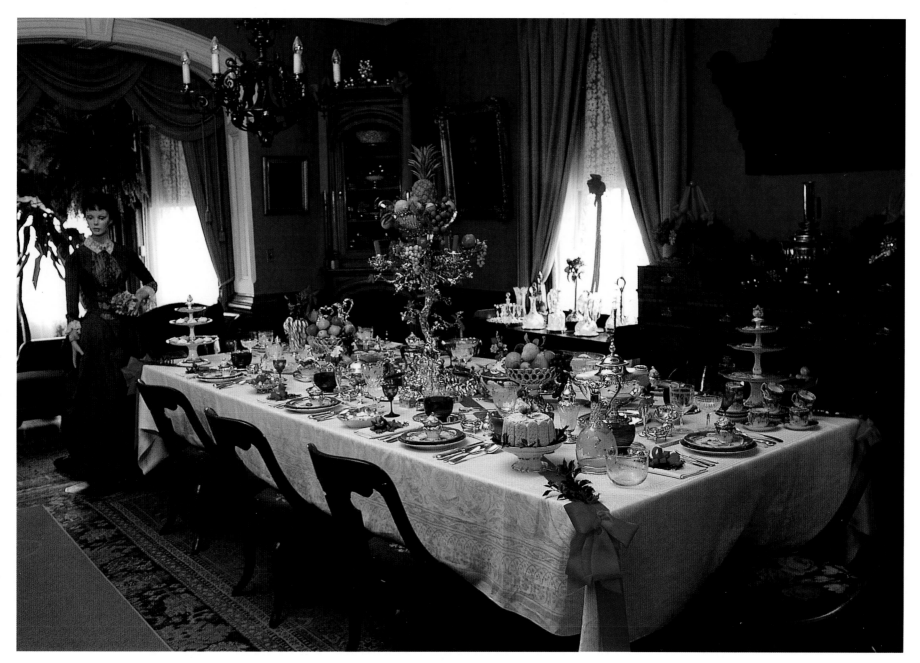

SEWARD HOUSE, AUBURN

*Holiday table set with French china, Old Paris pattern, purchased in
New York City in 1855, and flatware purchased in Albany in 1838,
when Seward was Governor of New York State.*

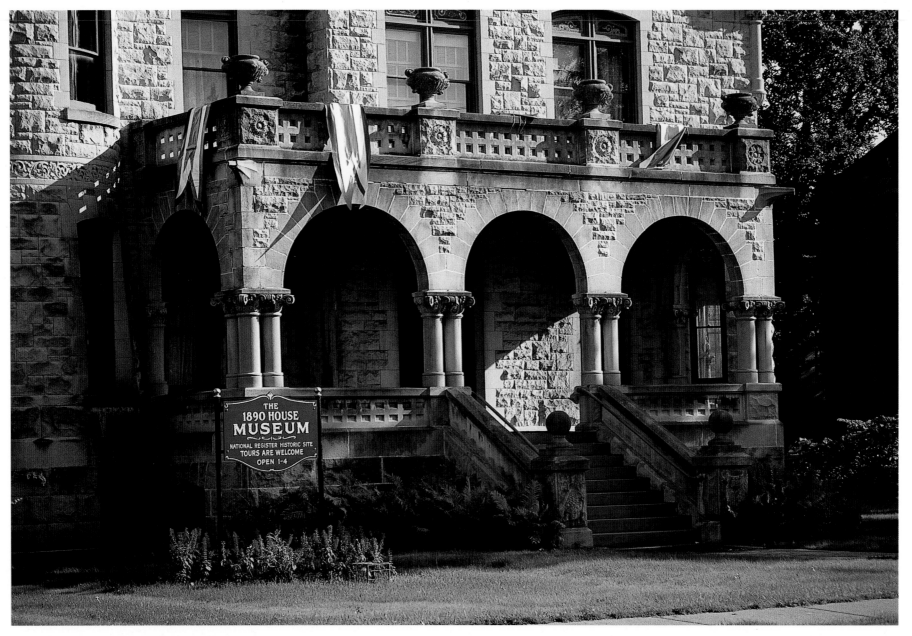

1890 House

Cortland

A glimpse of life at the turn of the last century.

HONEOYE FALLS ON A LAZY SUMMER DAY

Monroe County

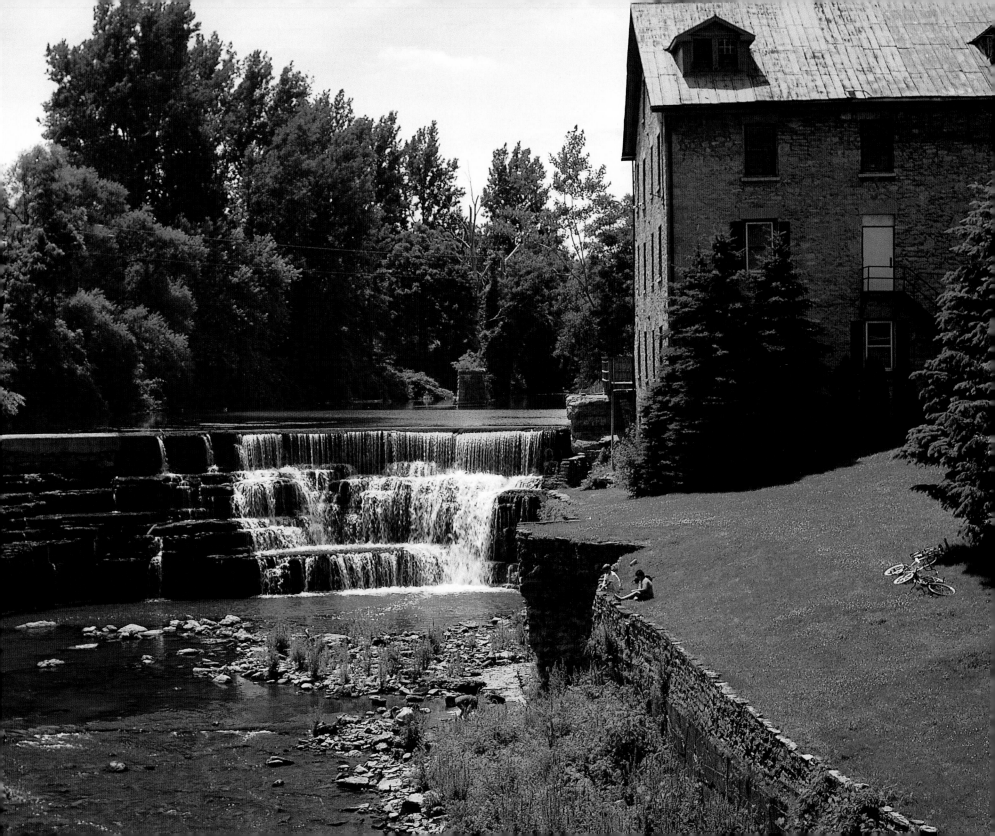

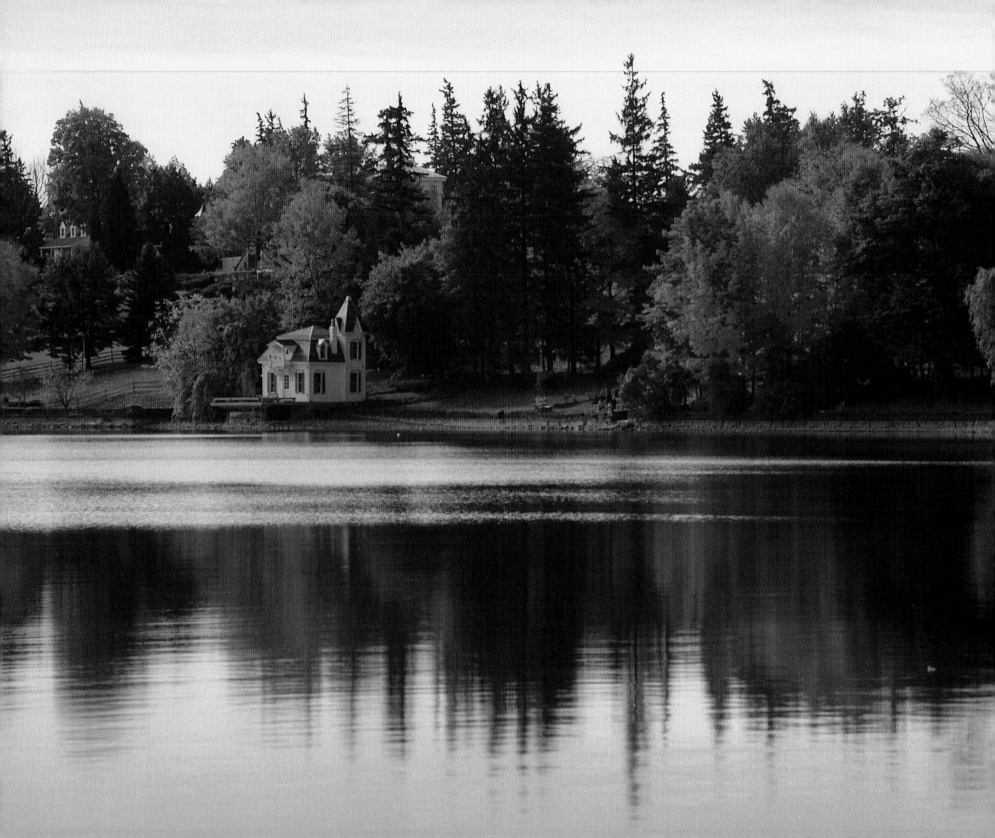

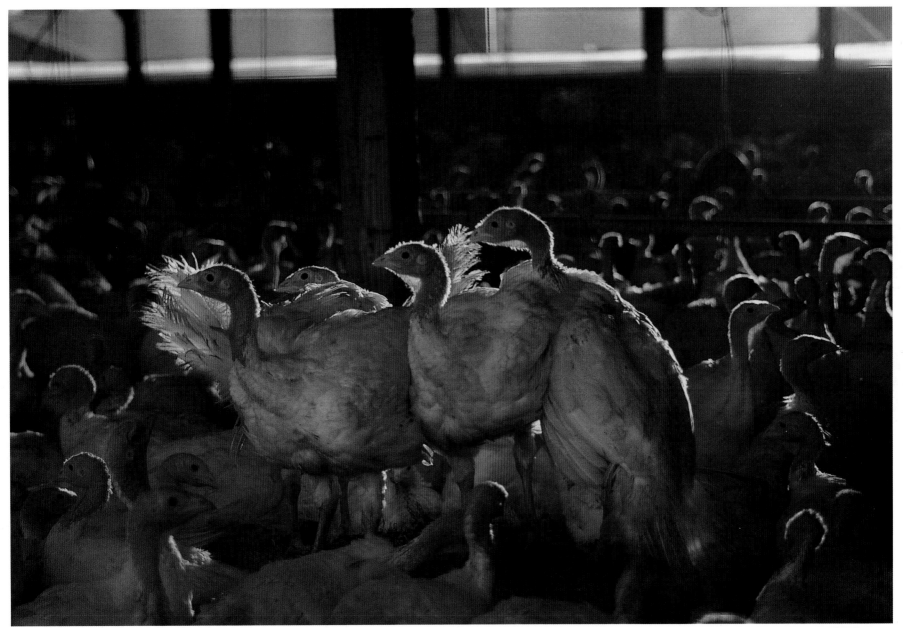

TURKEY CAUCUS

Plainville

WESTSHORE, SKANEATELES LAKE

This elegant boathouse is believed to have been built by the
Society of Friends (about 1850) as a house of worship, and moved to
its present site from West Lake Road.

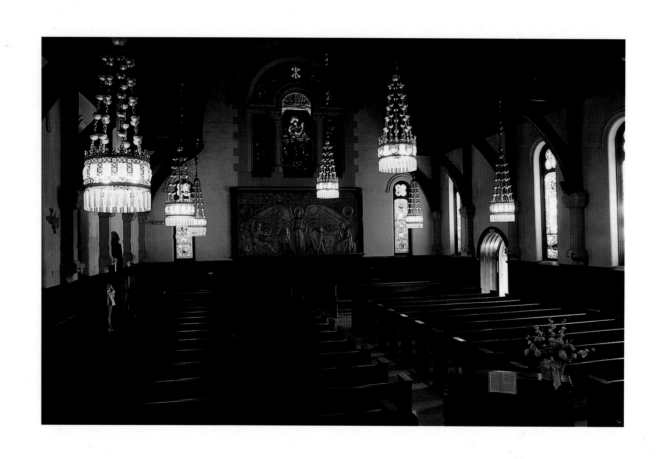

WILLARD CHAPEL, AUBURN

*Louis C. Tiffany's Glass and Decorating Company designed and
hand-crafted this chapel, completed in 1894, for the Auburn
Theological Seminary. Tiffany experts believe it is the only remaining
example of a complete Tiffany interior.*

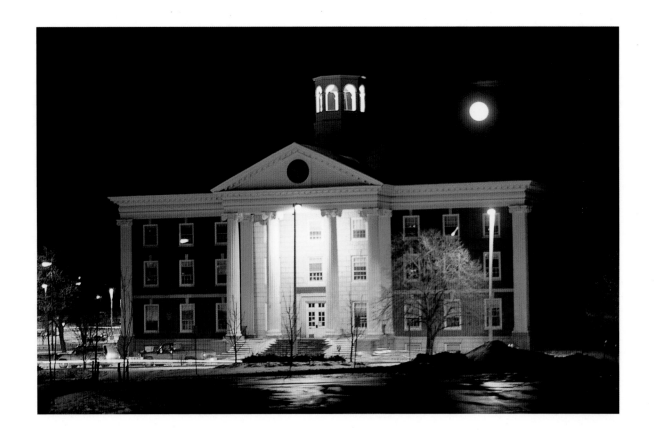

MEMORIAL CITY HALL, AUBURN

Photographed on a bitter cold Jamuary night.

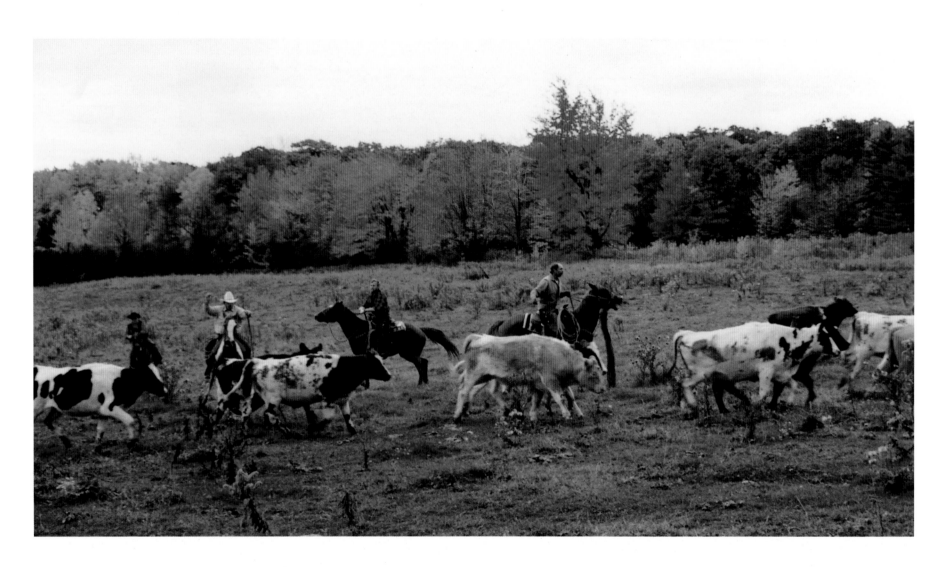

COWBOYS, FINGER LAKES NATIONAL FOREST

Hector, Seneca County
Farms abandoned during the Great Depression are the core of
this 14,000 acre forest where local ranchers graze their herds
for several months before the annual autumn roundup.

Private Abijah Virgil's Plot

Stonehedge Golf Course, Groton
Virgil served in the Battle of Princeton, the Battle of Saratoga
and the taking of British General Burgoyne.

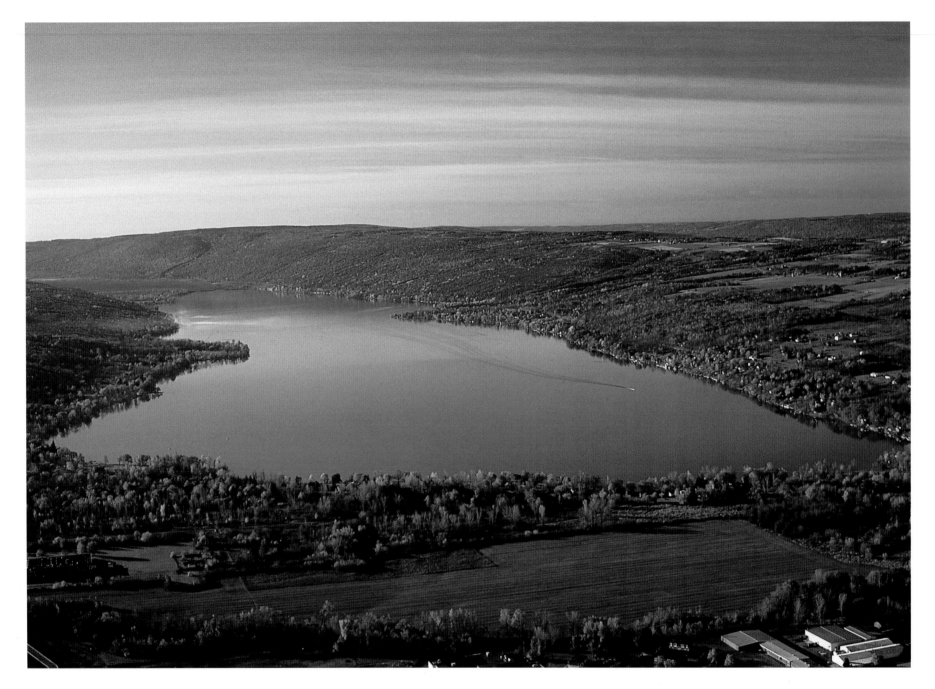

HONEOYE LAKE

Five miles long, 30 feet deep.
The Indians named the lake "Lying Finger" because of its shape.

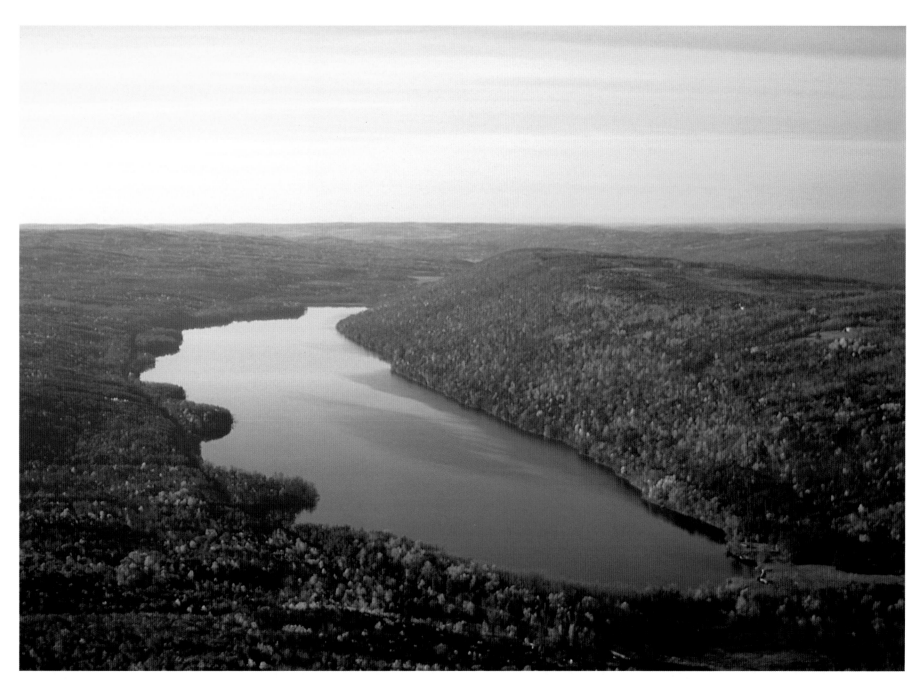

CANADICE LAKE

Three miles long, 91 feet deep.
The Indians called it "Long Lake."

FEEDING TIME

New Hope, Skaneateles Lake
"And Solomon's provision for one day was thirty
measures of fine flour, and threescore measures of
meal. Ten fat oxen, and twenty oxen of the pastures,
and an hundred sheep, besides harts and roebucks,
and fallowdeer..." — 1 Kings 4, v. 22-23

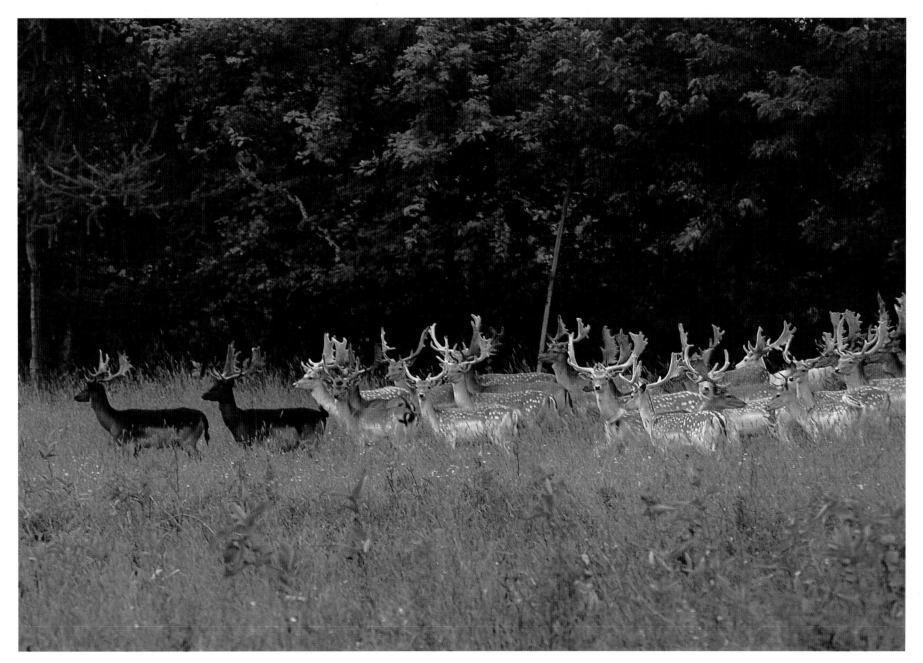

FALLOWDEER, NEW HOPE

This hearty breed has been around since Noah beached the Ark,
and while, in other breeds, nature camouflages only fawns,
Fallowdeer never lose their spots.

Vine Valley

Yates County

WINTER FARM

Canandaigua Lake

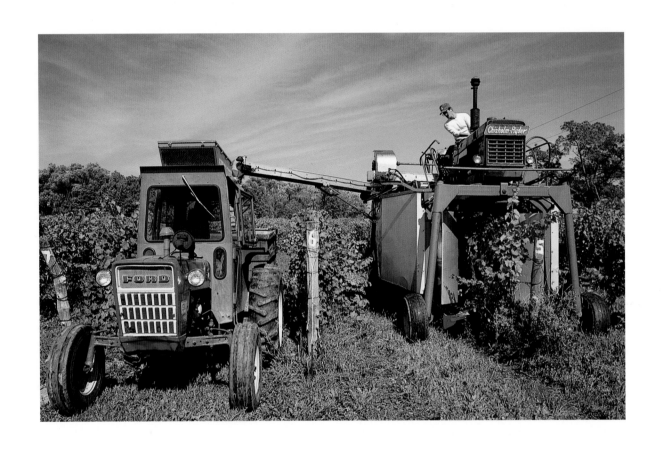

GRAPE HARVEST, SENECA COUNTY

Since the early 1970's, grapes from Finger Lakes vineyards have been harvested mechanically. This machine gathers 10 tons of grapes an hour, for a yield of nearly 2,000 gallons of wine.

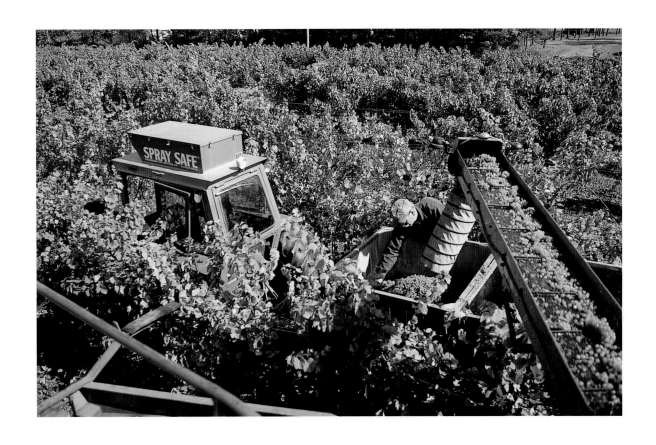

FILLING THE TOLES, SENECA COUNTY

*Warm days and cool nights on these glacially-tilled hillsides
are ideal for cultivating grapes.*

SUMMER AFTERNOON

Skaneateles Lake

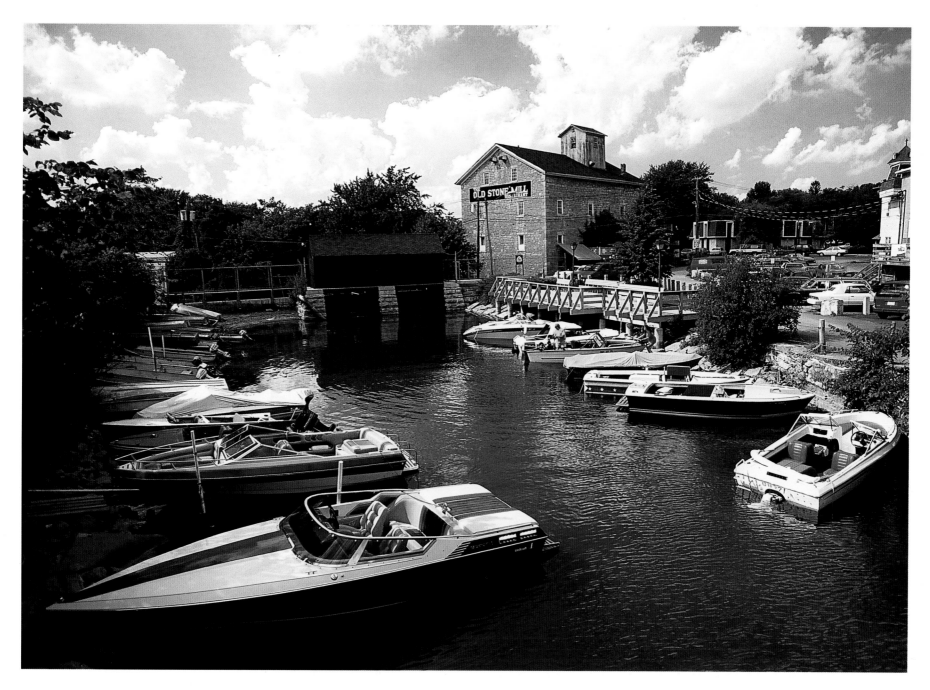

THE OLD STONE MILL, SKANEATELES

In the early 19th century, waterpower along the outlet spawned gristmills, sawmills, tanneries and at least one distillery.

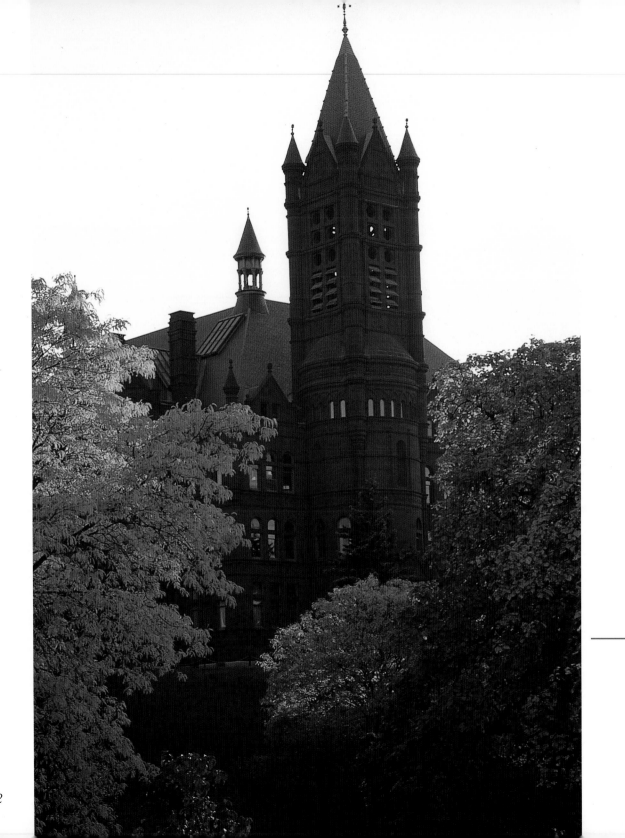

CROUSE COLLEGE

Syracuse University

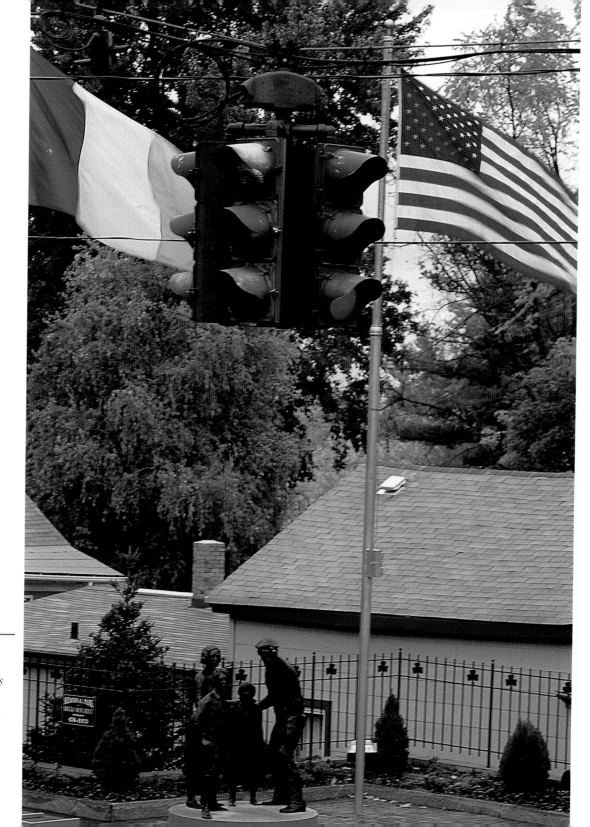

Tipperary Hill

Syracuse
Since 1929, this traffic signal has featured the green lens over the red to commemorate the Hill's first settlers, Irish immigrants from County Tipperary. Initial efforts to replace the green lens were met with sustained resistance from a group known as the "Stone Throwers." The Stone Throwers monument was dedicated in 1996.

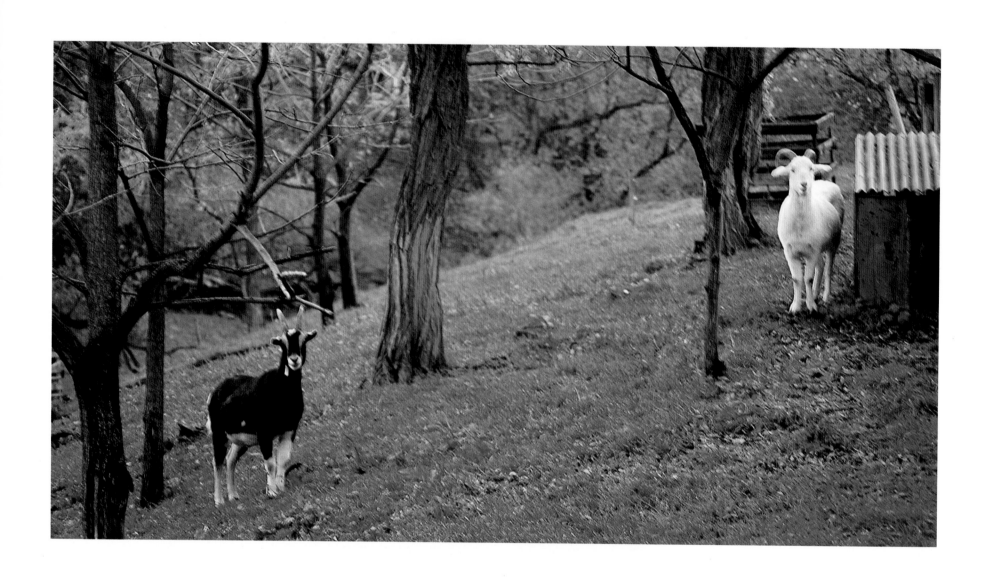

CURIOUS

Skinny and Scooter on Rockefeller Road,
Cayuga County.

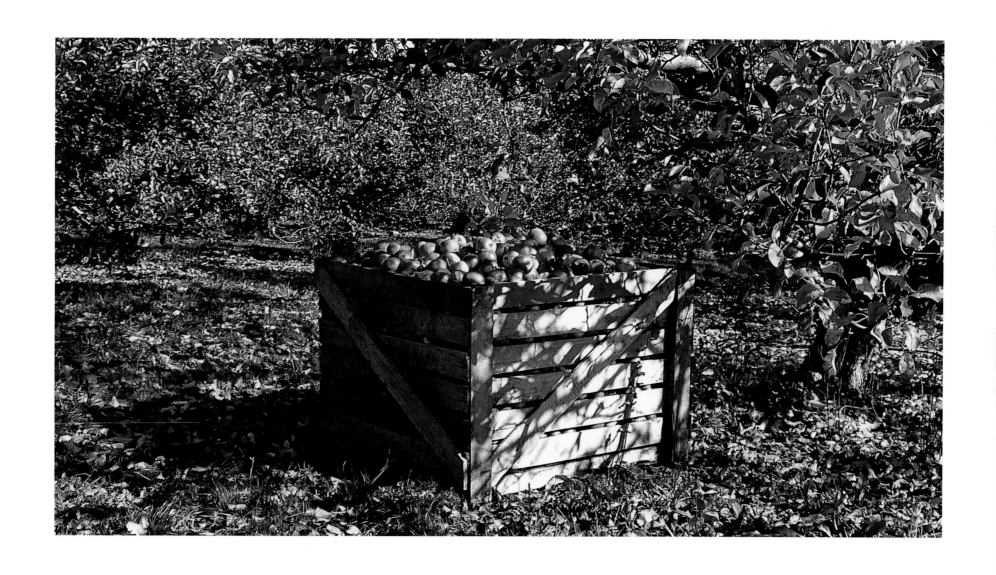

APPLE HARVEST, WAYNE COUNTY

*There are miles of fruit orchards along the roads to
Sodus Bay and Lake Ontario.*

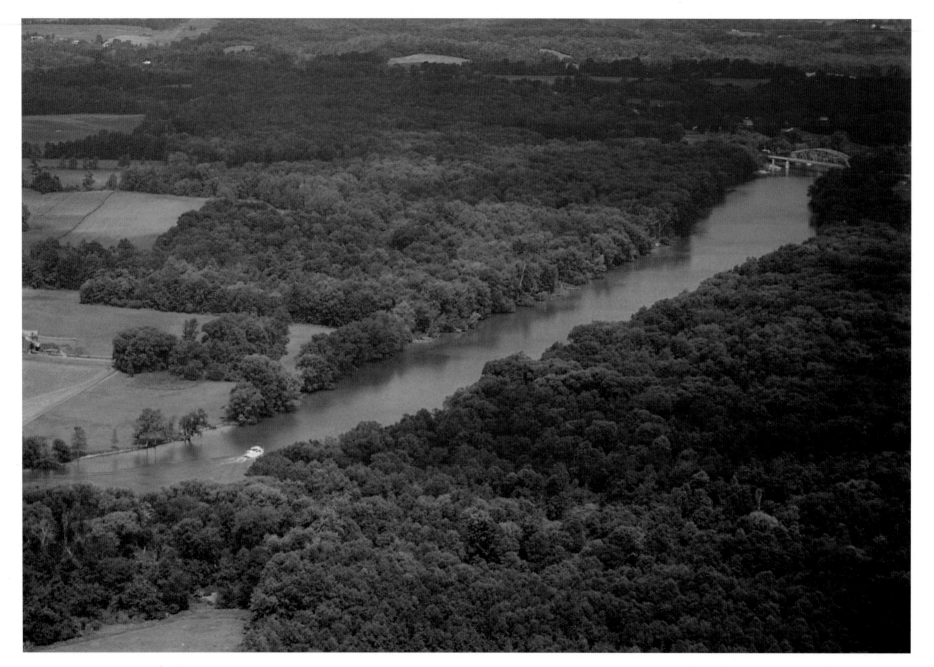

ERIE CANAL

Francis Kimball, in his book New York – The Canal State, *wrote,
"The Erie Canal rubbed Aladdin's lamp. America awoke, catching for
the first time the wondrous vision of its own dimension and power."*

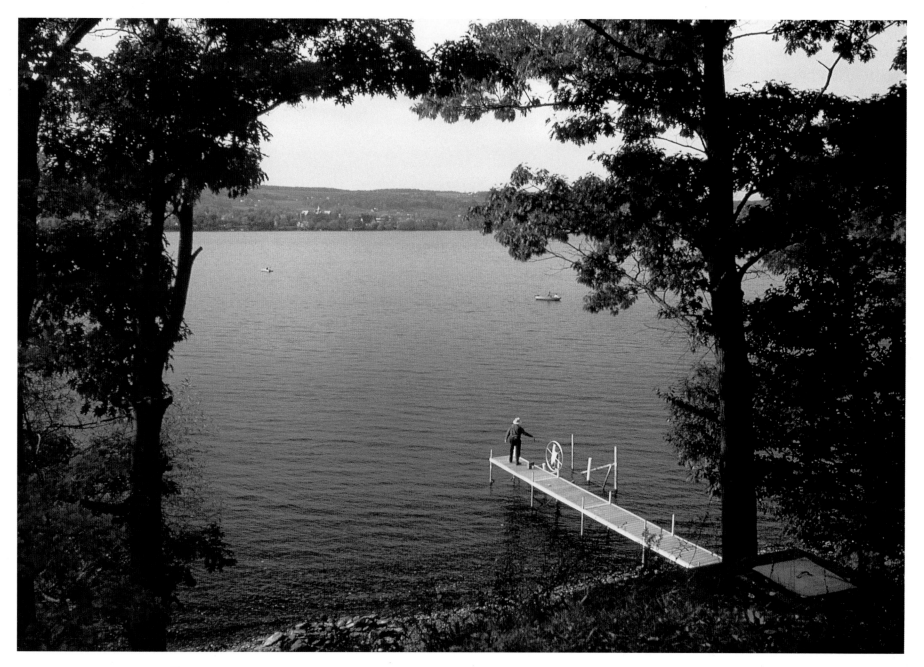

FISHERMAN

Keuka Lake
Keuka College can be seen in the background.

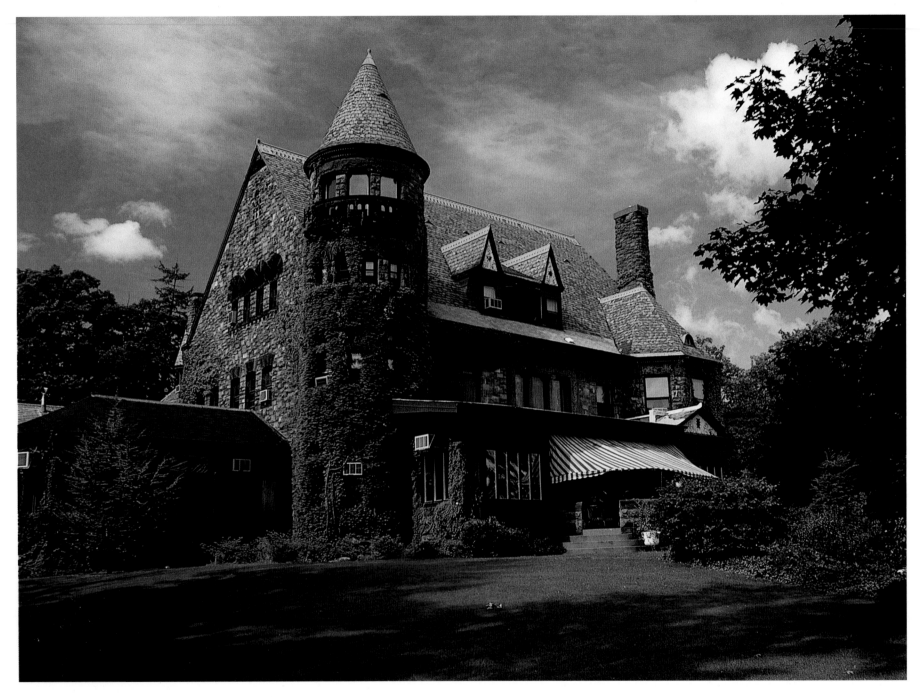

BELHURST CASTLE

Geneva

BROWSERS

Hammondsport

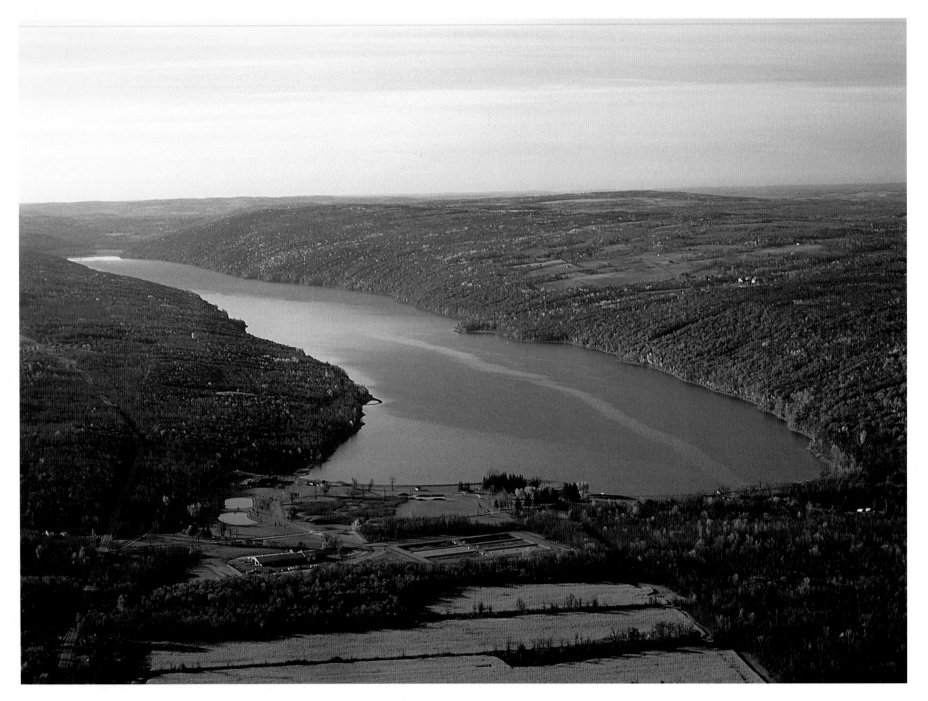

HEMLOCK LAKE

Eight miles long, 96 feet deep.

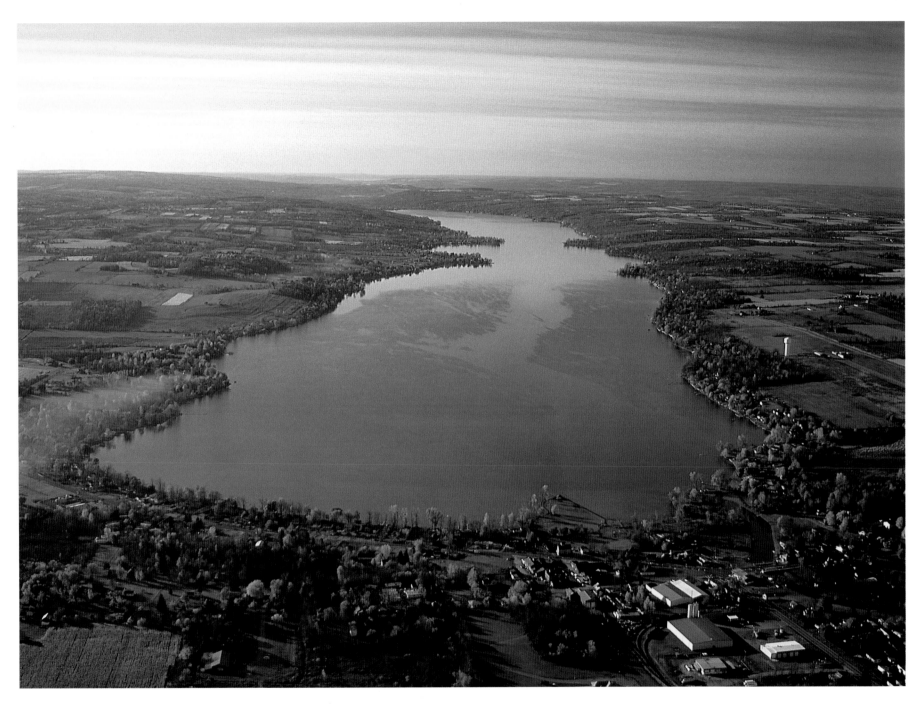

CONESUS LAKE

Nine miles long, 59 feet deep.

DUCKS & GEESE

Canandaigua Lake
At first the ducks seemed to be part of the breakwater,
and then the wind came up and they drifted apart.

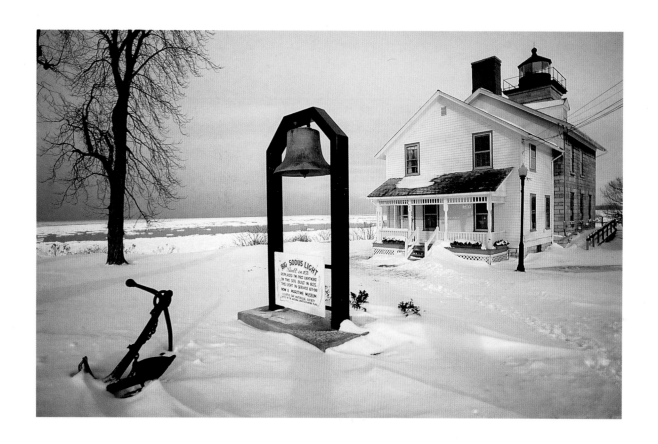

HISTORIC LIGHTHOUSE

Sodus Point
Our first Finger Lakes book included the new Sodus lighthouse,
built farther out on the point. For that image, we had to endure
deep snow and severe windchill. The icicles on the breakwater
looked like shark's teeth. This time around, older and wiser,
we opted for a softer, gentler composition.

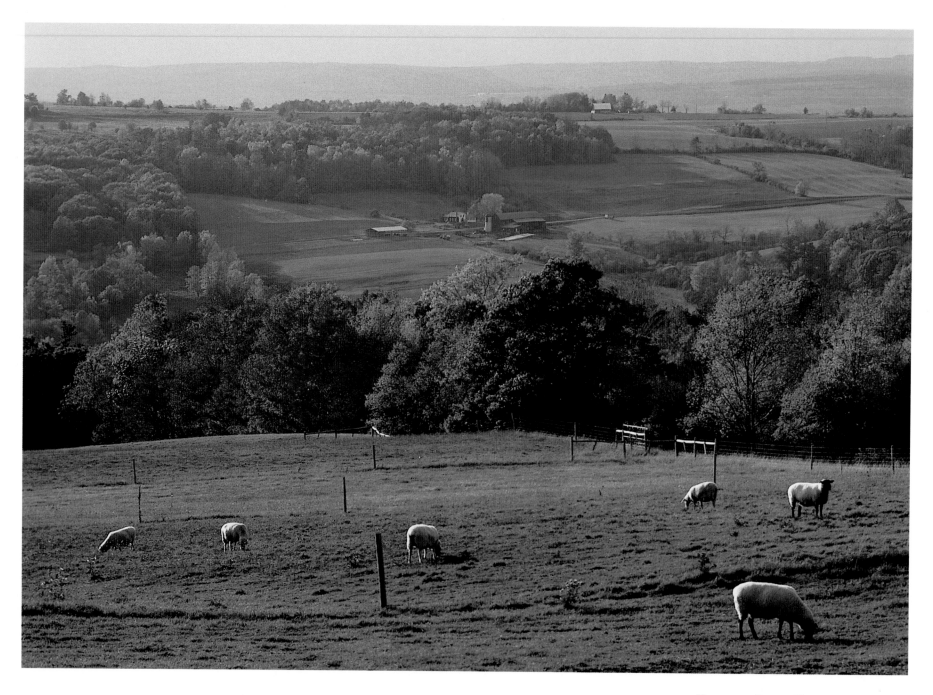

GRAZING SHEEP, DUNDEE

*The first settlers named their new home after
their old one in Dundee, Scotland.*